IMAGES
of America

AROUND
FISHKILL

E

BEAVER

PONDS

WIGWAM

STORE HOUSE

A PLAINE

A SWAMPE

WAPPINGERS CREEK

A PLAINE

A PLAINE

THE HIGH LANDS

A SPRING

N

WIGWAM

WIGWAM

A PLAINE

A PLAINE

WIGWAM

THE FALLS

YE FRENCHMANS

THE FALLS

SURVEYED & DELINEATED BY ME JOHN HOLWELL SURVEYOR APRIL 1st ANNO DOMINI 1689

W

A SCALE OF FURLONGS.

HUDSON'S RIVER.

1. Facsimilies of the signatures of Verplanck and Romboudt on the deed from the Wappinger Indians to them in 1683.

Guilain Verplancke

Francois Rombouts

There were only a few squatters, hunters and fishermen living near the mouth of the Wappinger Creek, when the Bretts built their mill at the mouth of the Fishkill Creek in the Southwest corner of the Rombout Patent in 1708.

IMAGES
of America

AROUND
FISHKILL

The Fishkill Historical Society

ARCADIA
PUBLISHING

Copyright © 1996 by the Fishkill Historical Society
ISBN 978-0-7385-6378-7

Published by Arcadia Publishing
Charleston, South Carolina

Printed in the United States of America

Library of Congress Catalog Card Number: 2008938085

For all general information contact Arcadia Publishing at:
Telephone 843-853-2070
Fax 843-853-0044
E-mail sales@arcadiapublishing.com
For customer service and orders:
Toll-Free 1-888-313-2665

Visit us on the Internet at www.arcadiapublishing.com

Contents

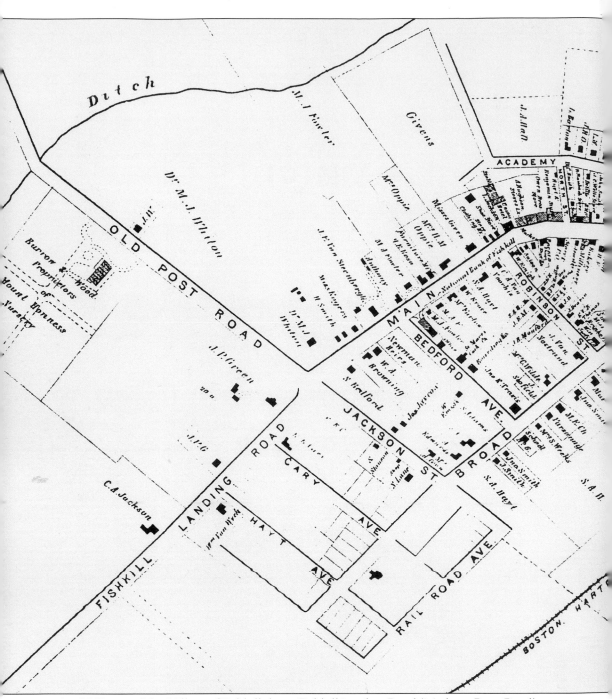

An 1867 map of the Village of Fishkill shows Fishkill Landing Road (Madame Brett Road), now Route 52. On the right, passing by the Van Wyck Homestead, one can also see the Highland

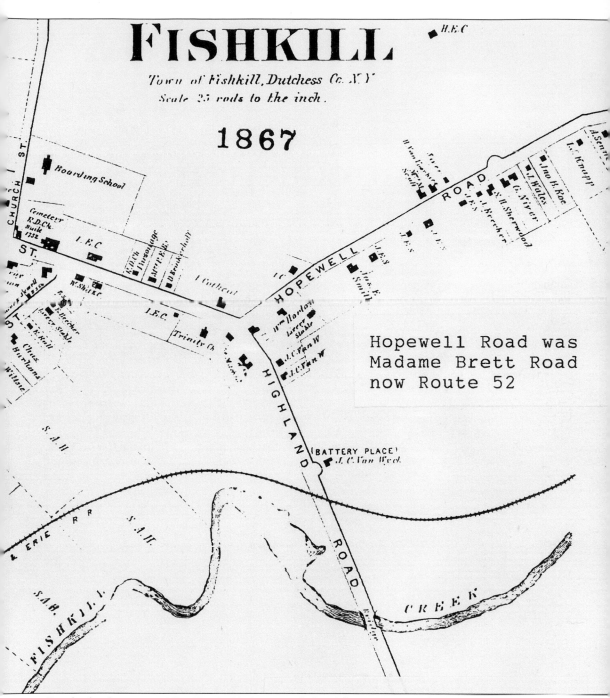

Hopewell Road was
Madame Brett Road
now Route 52

Road, also known as The King's Highway and the Albany Post Road. Today, the Highland Road is known as Route 9.

Introduction

Fishkill covers only a small portion of the Rombout Patent, but it played a large role in shaping the destiny of Dutchess County. The Rombout Patent was the largest and first portion of Dutchess County to be licensed for purchase from the Wappinger Indians. The buyers were two well-to-do merchants who received their Crown patent in 1685. The 85,000 acres, purchased for approximately $1,250 by Francis Rombout and Gulian Verplanck, covered the southernmost, pie-shaped land area of Dutchess County, which today includes the city of Beacon; the village of Fishkill; and the hamlets of Dutchess Junction, Glenham, and Brinckerhoff. The towns of Wappingers and East Fishkill were part of the original land grant.

Catharyna Brett, the daughter of Francis Rombout, was sole heir to her father's portion of the patent. She and her husband, a former British naval officer, built a home and mill on land near the mouth of the Fishkill Creek, in what is now the city of Beacon. After her husband, Roger, drowned in a boating accident caused by a violent storm on the Hudson, Madame Brett was left a young widow with three sons to raise and a mortgage to pay. In order to resolve this financial crisis, she sold tracts of land to other settlers. Homesteads soon spread eastward from Fishkill as more settlers came into the area. The population, which had been several hundred, rose rapidly to seven thousand during the Revolutionary War period. At the turn of the twentieth century, the population was 589, but on the rise. Our 1990 statistics show we have 2,000 residents in the village. Despite these various changes in size, the village still enjoys many small-community amenities. Our local school, library, police and fire services help promote this closeness.

We hope you enjoy your journey through Fishkill.

The Fishkill Historical Society
April 30, 1996

8

One

Along the Madame Brett Road

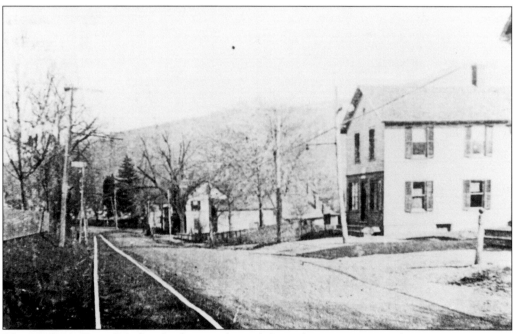

The Madame Brett Road started as single trail from the Wappinger Indian encampment in Fishkill Plains to the Brett Mill at the mouth of the Fishkill Creek. Used by Native Americans to bring their corn to the mill and later by settlers moving to the northeast, the road developed. By 1776, the village of Fishkill was the largest in Dutchess County. It had two churches, an academy, one schoolhouse, a hotel, and a printing press. The post office, one of only seven in the colonies, opened in 1789. This view shows the Madame Brett Road passing through Glenham in 1902.

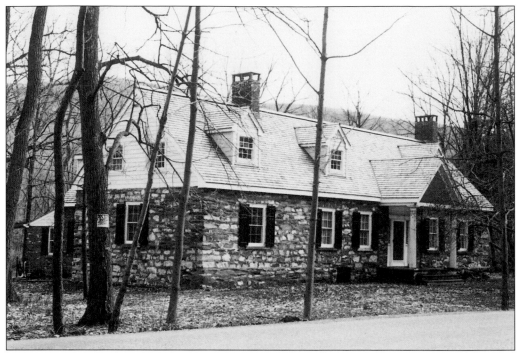

Henry Kipp lived here in the mid-eighteenth century. Baron Van Steuben reportedly stayed in the home several times during the American Revolution. The home has recently undergone extensive restoration work.

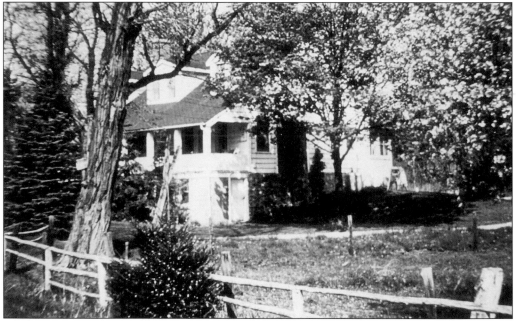

Zabalon Southard purchased two hundred acres, west of Fishkill Village, from Francis Brett. He built his home in 1776 and it retained many of the original feature for over two centuries. The home and farm remained in the Southard family until 1903, when it was purchased by the Geering family.

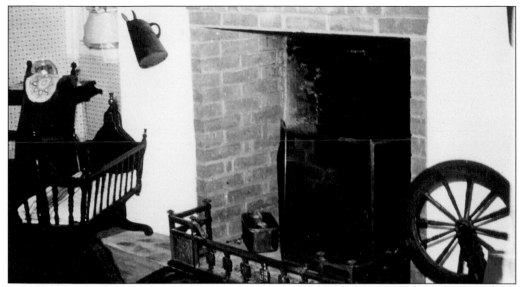

The Maurer and later Geering families continued farming the area around the home, which became known as Meadowbrook Farm. Their property grew smaller and smaller as roads were expanded and widened. The owners managed to keep the flavor of the home until the battle was lost in the 1980s, when the house, with its four working fireplaces, was removed to make way for the 84 Diner.

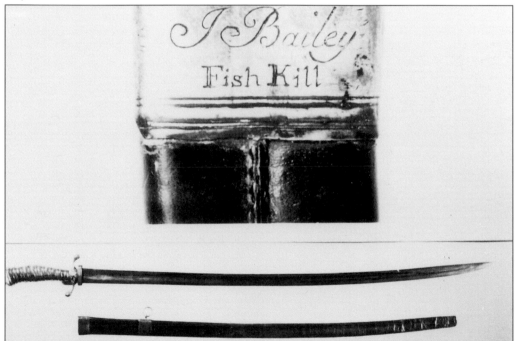

The war-sword made for General George Washington by John Bailey was crafted in his small shop on the banks of Forge Brook. The sword is three feet long and was light in weight. "J. Bailey, Fishkill" is engraved on the sheath. George Washington bequeathed his five swords to his five nephews. Samuel T. Washington received the Bailey-made sword. Samuel's son presented it to the Congress of the United States on February 8, 1843.

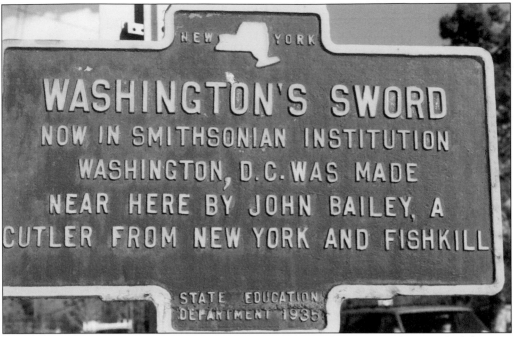

WASHINGTON'S SWORD NOW IN SMITHSONIAN INSTITUTION WASHINGTON, D.C. WAS MADE NEAR HERE BY JOHN BAILEY, A CUTLER FROM NEW YORK AND FISHKILL STATE EDUCATION DEPARTMENT 1935

John Bailey fled from New York with his family when British troops took control of the city. He settled just east of present-day Route 84 and set up his forge on the banks of the creek now called Forge Brook. He made and repaired swords for officers in the Revolutionary Army. Bailey repaired a sword for General Lafayette and did extensive work for the army depot in the area.

Dr. Bartow White was one of the most distinguished physicians in the southern portion of Dutchess County. He was born in Yorktown in 1776, and moved to Fishkill in 1799. He built this home in 1805. Dr. White represented Dutchess County in Congress from 1825–27. He suffered from epilepsy for fifteen years before his death in 1862. His home was demolished in 1966 to make way for Barkers Plaza and Department Store.

Judge Joseph J. Jackson's home on the corner of Main and Jackson Streets in Fishkill Village is presently owned by the Mid-Hudson Medical Group. During the Revolution, the property was owned by James Weeks, who had a tavern there. Later known as the Colonial Inn, it has been remodeled several times, starting as a Georgian structure, then Federal, with the upper part Hudson River Gothic (1840–60).

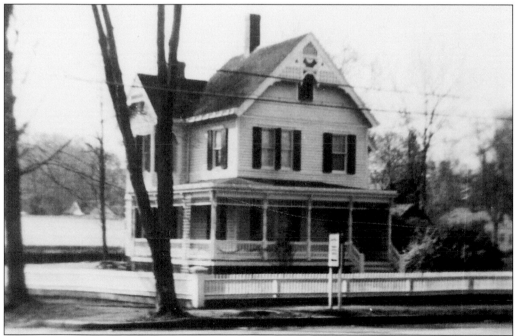

The DeWitt Smith House, on the corner of Main Street and Bedford Avenue, was the residence of DeWitt Smith, who operated a pharmacy on Main Street. Smithtown is named for his father, James Smith. This house still stands, surrounded by stores including the Alps Sweet Shop, Fishkill Wallpaper & Paint, and Fishkill Pet Shoppe.

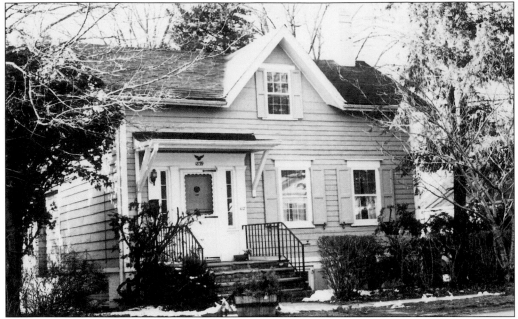

This clapboard home has original walls of brick. It was built in 1839. The original kitchen is in the basement. A newer kitchen was included in a small room in the rear of the first floor. The loft, or second floor, contains two bedrooms that were originally reached by a ladder.

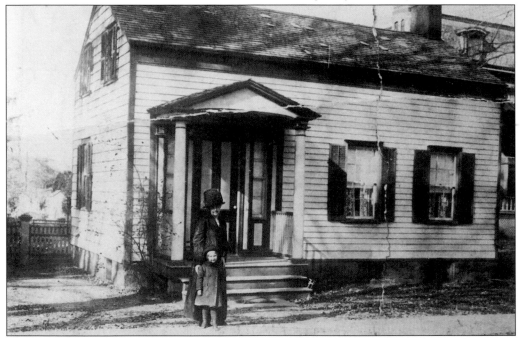

Built in 1830, this was the home of Mr. and Mrs. Edgar Shook. Mr. Shook was the son of William A. Shook, who owned and operated a large fruit farm near Wappingers Falls. The farm specialized in fruit, garden products, and bottled milk and cream from the herd of Jersey cows on the farm. Mrs. Maude Shook is pictured with her daughter, Marion (at age three), in front of the home in the early 1900s.

This is the Shook-Post House as it appears today. An addition was added to the back of the house. It is the residence of Marion Shook Post. The home on the left was taken down for the construction of Friendly's Restaurant.

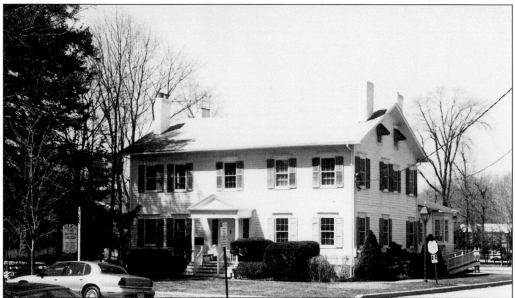

Shillelagh was the name that James Givens, a prosperous merchant from Ireland, gave his home. He built this Federal style house in 1812. Many of the leaded-glass panes are still in place. Mr. Givens was a school board member, active in the First Reformed Church, and he advocated the planting of elm trees along Main Street. Shillelagh escaped damage or loss in the great Main Street fire of 1873.

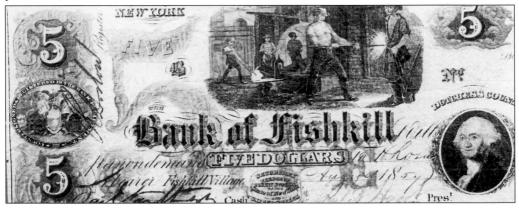

The Bank of Fishkill was constructed in 1858. It failed in 1877, following the national depression and economic decline in 1876. We are left with this certificate for purchase of shares at $100 per share (above), and a bank note for $5 (below).

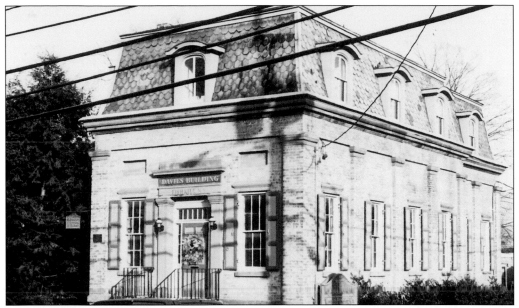

Built in 1858, this building has had various tenants, the first being the National Bank of Fishkill, which failed in 1877. Between 1886 and 1944, it was a dry goods store owned by James Dean. In 1944, it was sold by the Dean heirs to the Town of Fishkill, and used for the town offices until 1989, when a new town hall was built. Its last tenant/owner was the Davies Realty office. In 1996, the building is once again on the market.

Adriance House on Main Street was taken down in February 1972 to create an entrance for the Olde Post Mall Apartments. The house was built in 1840 by James Oppie, a lawyer and postmaster. His daughter ran a small circulating library from the home before a public library was established in this area.

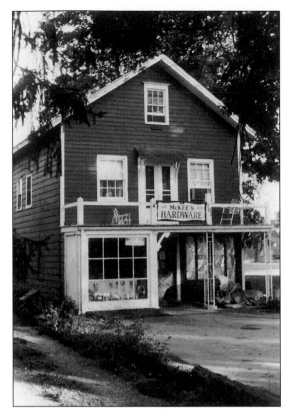

This was the oldest commercial building in the village until a few years ago when it was replaced by a larger structure set further back from Main Street. Originally owned by the Ross family, it served as a cabinet and furniture making shop, funeral parlor, and casket-making store.

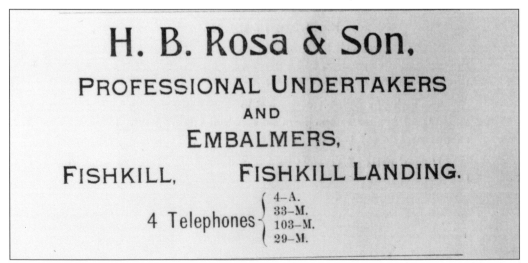

H. B. Rosa & Son,

PROFESSIONAL UNDERTAKERS

AND

EMBALMERS,

FISHKILL, FISHKILL LANDING.

4 Telephones { 4–A. 33–M. 103–M. 29–M.

This advertisement for the services of H.B. Rosa and Son was placed in the 1903 cookbook of the Stormville Union Chapel. The booklet sold for fifty cents.

Postmaster James Oppie used this building in 1856–58 as a combined law office and post office. The structure was taken down in 1972 for the construction of the Olde Post Mall Apartments.

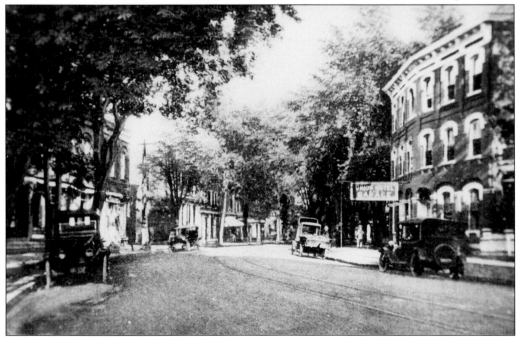

This is a view of Main Street, Fishkill, looking east, c. 1912. Note the trolley track down the center of the street. The Union Hotel is still in use in 1996, and is presently having a sandblasting face lift. It is now known as the Fishkill Inn. The stores on the left are still there and are basically serving the non-driving residents of the village.

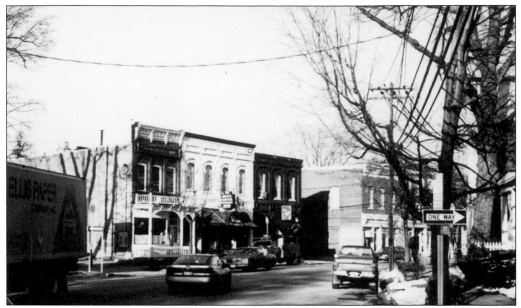

This view of Main Street in Fishkill, looking east in 1996, shows that surprisingly few changes have occurred. The trolley tracks may be gone, but you can see where they once were. Small shops still line the street for several blocks on both sides.

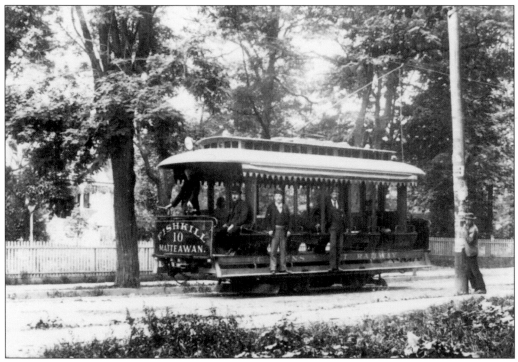

Five cents entitled you to a trolley ride between Fishkill and Mattewan, later part of Beacon. The trolley was the first overland transportation to connect the villages. This picture shows the trolley rolling into Fishkill Village in 1902.

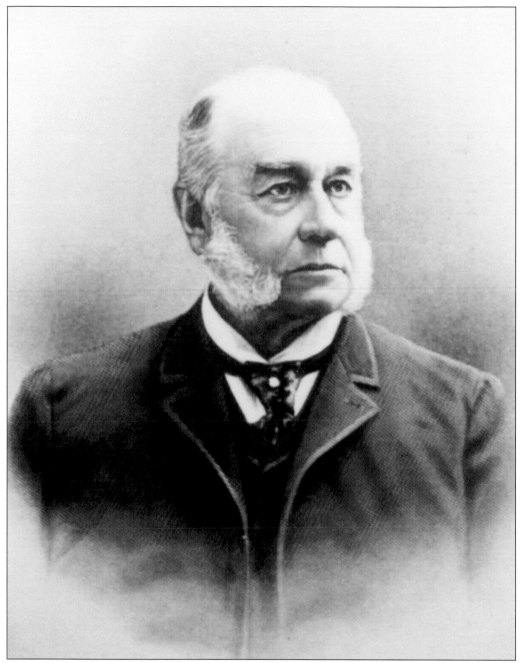

Henry DuBois Van Wyck sought his fortune in the gold fields of California and found it making gold watches for the miners. He returned to Fishkill, where he built Van Wyck Hall as a theater in 1898. When the village incorporated in 1899, he became the first mayor. Mr. Van Wyck operated a water bottling works at Knickerbocker Lodge on Van Wyck Lake Road. Bottled water was shipped from the Fishkill Railroad Station across the country. He died in 1902.

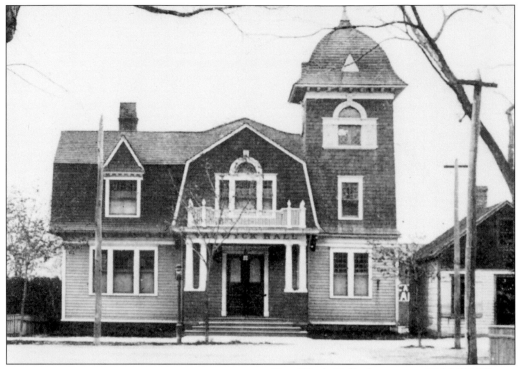

Van Wyck Hall, the present Fishkill Village Hall, was built in 1898 by Henry Dubois Van Wyck as a theater. After his death in 1902, it was given to the village and continued as the home of the Van Wyck Playhouse. Through the years it has been the scene of various activities, basketball games, dances, auctions, and social functions. Today it is headquarters for the village administrative offices and police station.

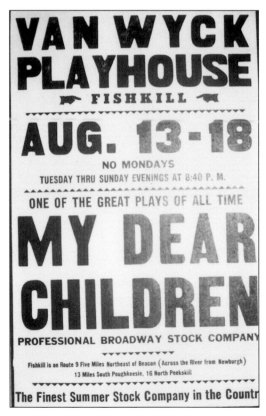

Fishkill audiences looked forward to evenings at the theater during the summers when professional touring companies performed at Van Wyck Hall. In this playbill, the Broadway stock company is billed as "The Finest Summer Stock Company in the Country."

In addition to professional actors, local people were often recruited as players, especially for musicals. Local residents would loan furniture from their homes as props. Shown here is a cast listing for the play *Aunt Julia's Pearls*, presented May 2, 1928, in which eight local people showed off their thespian talents.

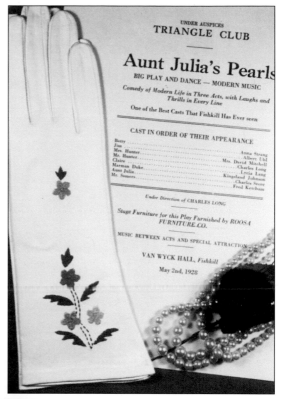

Mary Bogardus is shown reading the Declaration of Independence at Van Wyck Hall on July 4, 1963. This Fourth of July custom has been carried out since 1902, when the Van Wyck heirs, in giving the hall to the village, had the Declaration read as a tribute to their uncle's patriotism. It is still an unbroken tradition.

James Dean was born in Fishkill in 1830. He and his family owned a marble business on Church Street and they also ran the *Fishkill Weekly Times*. Mr. Dean was treasurer of the Fishkill Savings Institute; postmaster of Fishkill for twelve years; trustee of the Union Free School, District No.6; and an early promoter in the organization of the Fishkill Rural Cemetery.

The *Fishkill Weekly Times* was established in 1882 by James C. Dean. In 1888, his son, Herman Dean, became editor. The paper was a four-page, eight-column sheet, and remained independent from political affiliation.

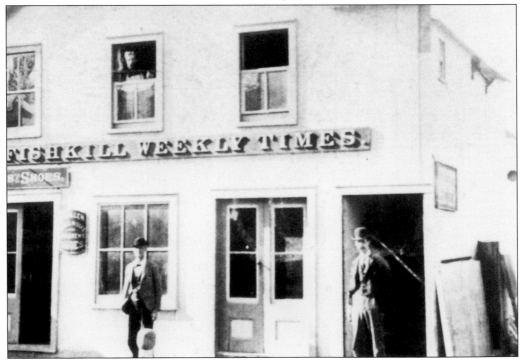

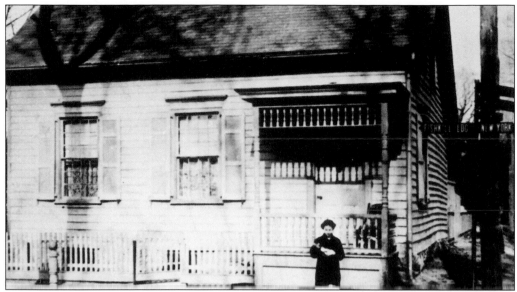

This clapboard house was situated on the corner of Main and Church Streets. The directional sign on the pole tells you Fishkill Landing is down the road to the left and New York is to the right. The interesting feature of the house is the origin of the wood. It came from the encampment barracks south of Fishkill. Dorothy Eastwood is shown standing before her home, which was taken down in 1930 or 1931.

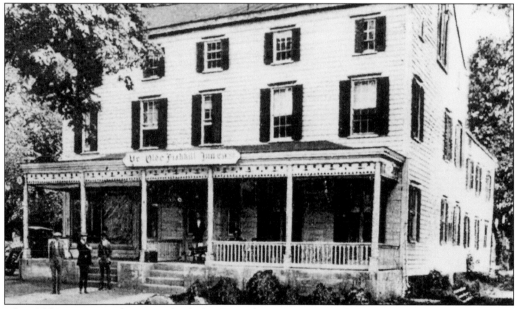

The Old Mansion House was built by Cornelius C. Van Wyck in 1789, and it is one of the oldest standing buildings in the village. It was a stage coach stop and inn on the King's Highway. Many alterations were made over the years to fit the needs of the time. Ye Olde Fishkill Inn opened on the first floor in 1865. The third floor, with Palladian windows on either end, was a large ballroom where many balls and political events transpired. The porch has been removed and stores built into the main floor. Presently, Dae Shoe Repair, A-Copy-A-Second, and the chiropractic office of Dr. L.J. Molomot occupy the first floor.

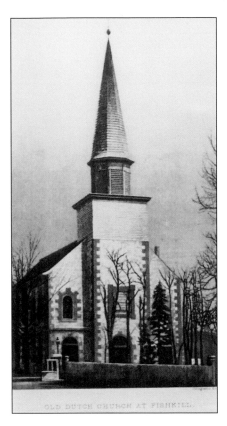

OLD DUTCH CHURCH AT FISHKILL.

This is a view of the First Reformed Church of Fishkill, c.1915, at about the time the church was converted from gas lighting to electricity. Founded in 1716, the first church building was completed in 1731. It was considerably smaller, with a hip roof and a cupola with a bell in the center. The New York Provincial Congress met here from September 1776 to February 1777, making Fishkill the temporary capital of New York State. Later, during the Revolutionary War, the church was used as a military prison. The small original structure was incorporated into the rectangular structure of today.

The Chapel of the First First Reformed Church was built in 1872. It held Sunday school and was used for all church social functions. Taken down in 1964, it was replaced by the present education building.

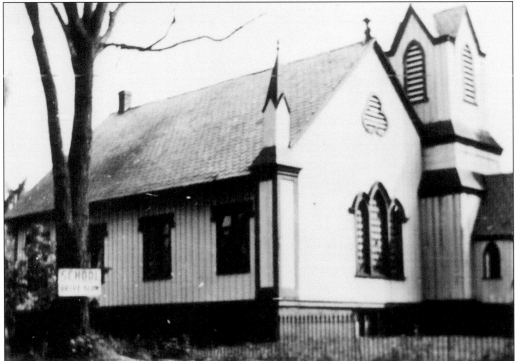

This stone slab over the doorway of the First Reformed Church was made by Dean's Marble Works and is inscribed with significant dates in the church's history. The structure's fieldstone walls are 3 feet thick and some of the original window glass panes remain. Madame Brett is buried under the pulpit.

Rising 120 feet above the ground, this spindle, ball, and weathercock were purchased for £46.145.2 and placed on the steeple of the First Reformed Church. The rooster stands as a symbol of Peter's denial of Jesus. The weathervane and ball were removed when the steeple was struck by lightning in 1921, and repairs to the spire were underway. They were taken down again in 1984 for re-gilding and remain today as a landmark that can be seen when approaching the village from every direction.

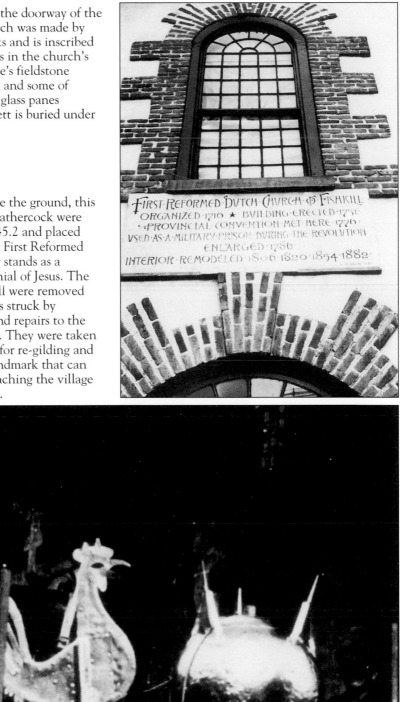

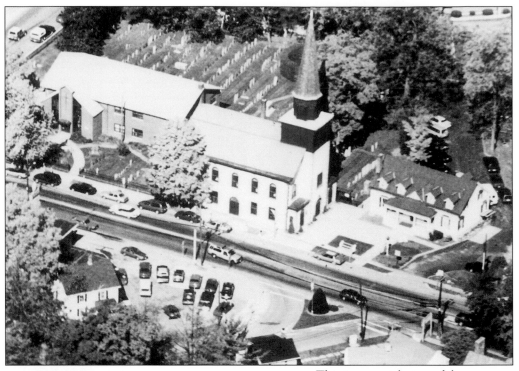

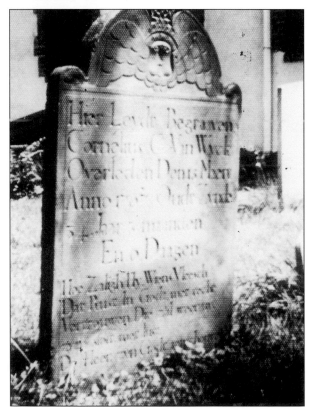

This is an aerial view of the Madame Brett Road, showing the First First Reformed Church with Ketcham Motors across the street. In the background, the rows of gravestones in the church cemetery can be seen. Sometimes called the Fishkill Landing Road, the Madame Brett Road formed a junction with the Albany Post Road which led to the formation of a village there during the early years of settlement.

This Dutch headstone in the First Reformed Churchyard reads, "Here lies buried Cornelius C. Van Wyck who died 1767, aged 34 years, 3 mos." Those interested in discovering more about the Dutch headstones in Fishkill are directed to the Blodgett Memorial Library, which has a book containing English translations for the inscriptions on many of the stones.

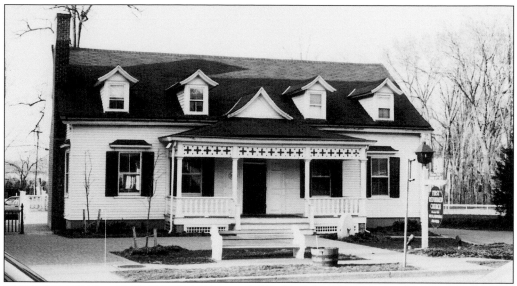

The Dubois House, at 55 Main Street, was built around 1750 and was moved to its present location next to the First Reformed Church in 1928–29, when the Albany Post Road (Route 9) was improved and hard-surfaced. The Committee of Safety met here during the Revolutionary War. A spy, Enoch Crosby, secretly reported on Tory activities before the Committee. In 1790, Abraham Rapalje purchased the house with 54 acres from Abraham Brinckerhoff. Rapalje built the steeple, altar, and pews in the First Reformed Church and was Fishkill postmaster. The building is now owned by the First Reformed Church.

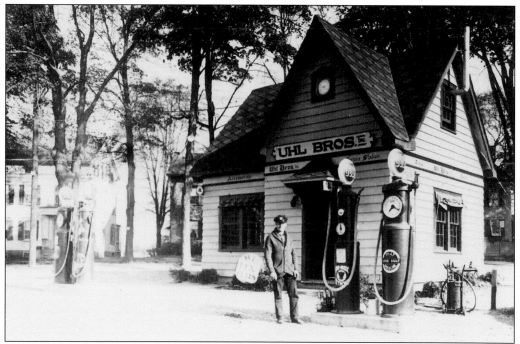

This gas station and garage was located at the junction of Routes 9 and 52 in the 1930s. It was owned by the Uhl brothers, who ran the station. Al Uhl is pictured here, proudly standing before the station before it was taken down to widen Route 9 in 1979.

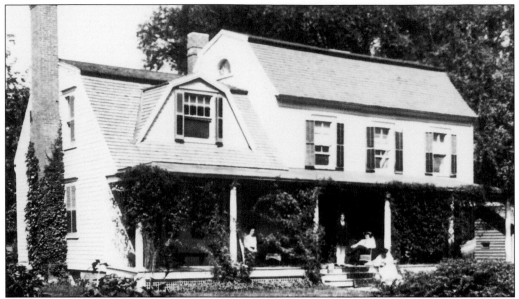

Abraham Rapalje, a merchant and postmaster in Fishkill, built this house as a storehouse in 1790. He lived in the DuBois House, which today stands next door to the First Reformed Church and is now owned by the church. When the church was rebuilding and expanding its building in 1785–95, Rapalje was hired by the consistory to build the pews and the steeple. He expanded his land holdings to 204 acres that included what are now the Homesites housing development and the Shop Rite Plaza.

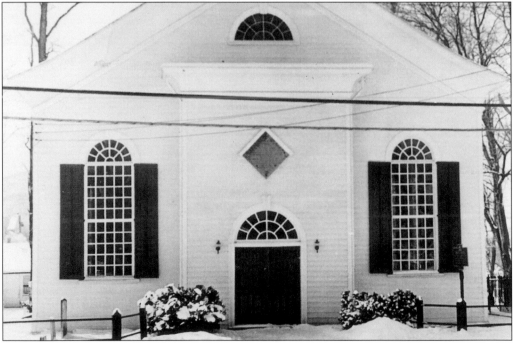

Trinity Episcopal Church is located along Route 52 in the village. Early in the Revolution, its congregation and minister were ostracized because of their Tory affiliation. The church was built in 1769.

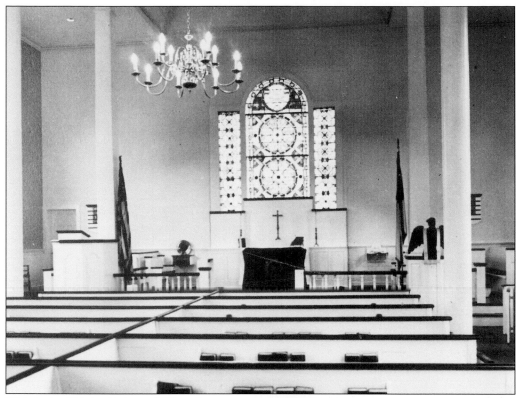

This is the Trinity Episcopal Church interior following a major restoration in 1962. During the Revolution, the Provincial Congress met at the church, which also served as a military hospital. However, because there were no windows, birds flying in and out were a problem.

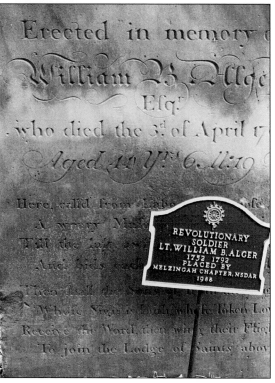

One hundred and ninety-six years after his death, Lt. William B. Alger was honored by Melzingah Chapter, DAR, in gravesite ceremonies at Trinity Episcopal Church. William Alger, born in Lyme, Connecticut, was living in Fishkill in 1775 when the War for Independence began. He signed the Articles of Association, a document bearing signatures of those who supported the war. After the war, he was a vestryman of Trinity Church and now lies buried in the churchyard.

One of the oldest residences in the village of Fishkill, the house on Rapalje Road and Hopewell Avenue dates to about 1803. It was a private boarding school when it stood in the graveyard of the First Reformed Church. The church's pastor and principal from 1805–30 was Dr. Westbrook, and the teacher was Miss Mary Bunce, a "maiden lady" from Connecticut who taught young scholars of both sexes. Miss Bunce died in 1839, and with no one to take her place, the schoolhouse was moved to its present location.

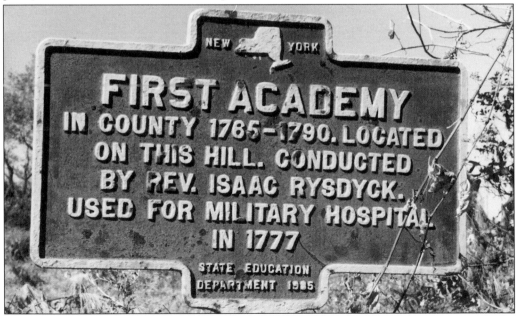

The first academy in Dutchess County, located midway between Fishkill and Brinckerhoffville, was run by Reverend Isaac Rysdyck and Reverend Graham. It was connected with the Presbyterian Church nearby. The academy moved to Poughkeepsie after the Revolutionary War.

Two

Growing Up
in Fishkill

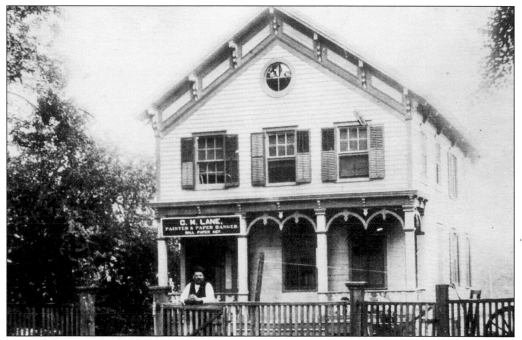

The 1840 Second Village School building was used until 1870, when the brick school building was erected on Church Street. Later the business of C.M. Lane, the structure was demolished in 1976.

Going courting?

This structure was originally two houses. They were late Georgian style with plain, simple doors and windows. The empty lot to the right was the site of the second public school in Fishkill.

The Methodist Church is a Greek Revival building, erected between 1838–42. Federal influences show on the front door and the window frames. Methodists held meetings in private homes from the 1790s until the church was built. Rev. L.M. Winchell was the first pastor.

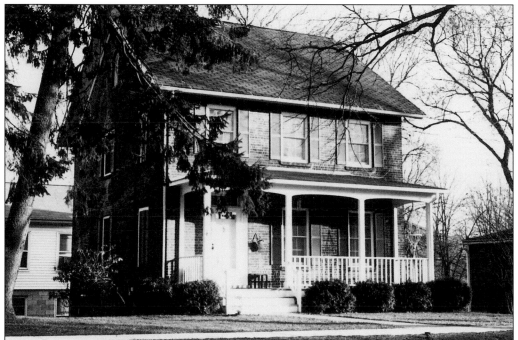

In 1865, the Methodist congregation built this house for their pastor and his family at a cost of $2,344. It is now a private home and the piano studio of Karen Hitt.

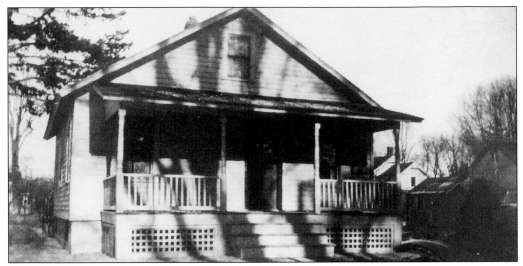

In 1925, Thomas and Edna Eckler proudly moved into their new home at 7 Cary Avenue.

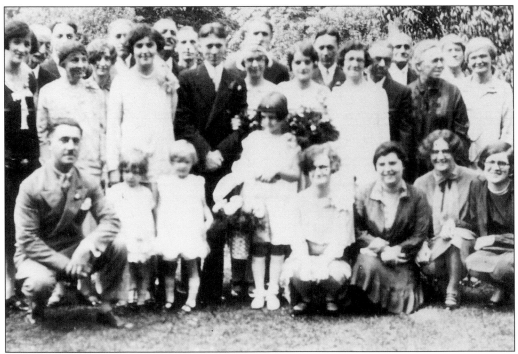

On September 3, 1927, Catherine Eckler and James Ortman were married in the Methodist Church by the Rev. Lang. Friends and family gathered at the home of the bride and groom for a reception.

Doris Long was photographed on Church Street as she was coming from Sunday school about 1925–26.

Why this picture was taken outside the First Reformed Church is unknown. The donor, Frederick Ketcham, MD, does recognize his grandfather as the first gentleman in the second row. Perhaps they were displaying Easter finery?

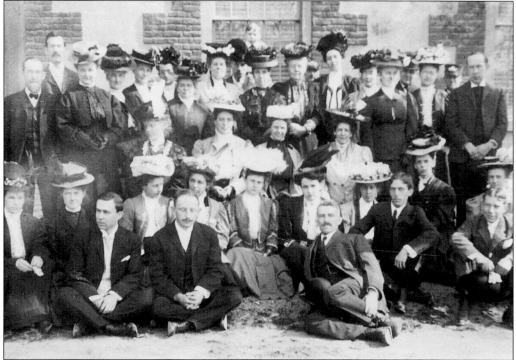

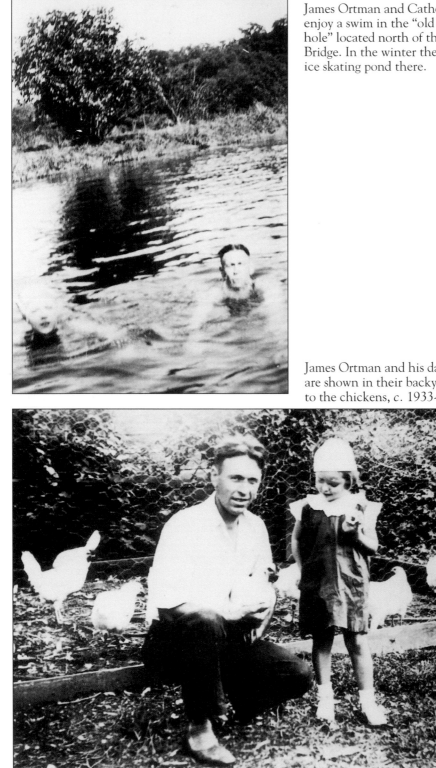

James Ortman and Catherine Eckler enjoy a swim in the "old swimming hole" located north of the Brinckerhoff Bridge. In the winter there was a great ice skating pond there.

James Ortman and his daughter, Diana, are shown in their backyard, "talking" to the chickens, c. 1933-34.

The home on Broad Street, Fishkill was constructed of hand-made bricks that were painted white. Federal stylistic touches can be seen on the facade. This house proudly displays a Dutchess County Landmark Plaque next to the front door.In the 1970s, it had been the home of Mayor Carl Erts.

Fourteen Broad Street. On a visit to grandma.

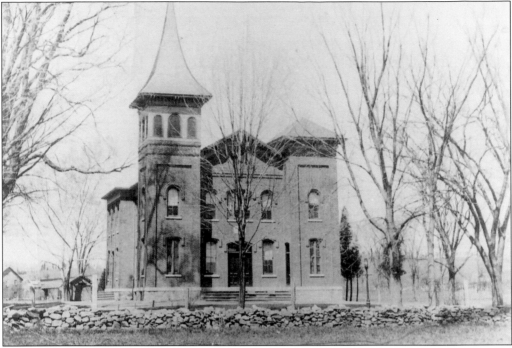

Fishkill's third school, the Union Free School No. 6, was established in 1866. The building was started in 1869 on three acres of land purchased on Church Street and the brick edifice was completed in 1872. The average student population was 231. In 1881 the school library had 300 volumes, altogether valued at only $50, and teachers' wages totaled $1,439.

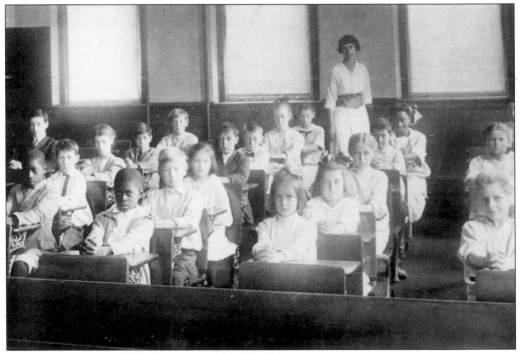

Prim and proper! Fishkill Elementary School in the 1920s.

Fishkill Elementary School fourth graders Curt Warren and Patrick Schorno.

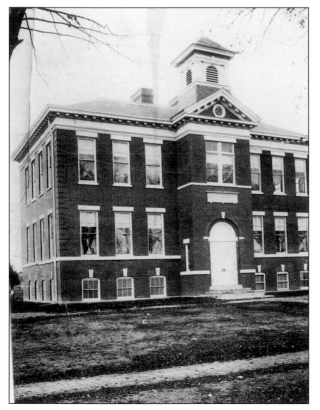

The fourth Fishkill School was designed by Charles Van Slyke of Beacon. It was built in 1910 to replace the older one, which burned in 1908. It became part of the Wappingers Central School District in 1940. To meet the growing population, additional rooms were added in 1952, 1954, and 1962. The student capacity is now about six hundred.

Fishkill Union School

Annual Commencement Exercises,

AT ACADEMY HALL,

Wednesday Afternoon, June 26th, 1895,

AT HALF-PAST TWO O'CLOCK.

CLASS OF 1895.

RUTH SHERWOOD, JESSIE D. HUGHSON
KATIE SAVAGE, GERTRUDE C. HAIGHT,
E. BELLE CLARK, DANIEL A. DUGAN.

Miss Shaw is the teacher on the right in this 1908 Fishkill School photograph.

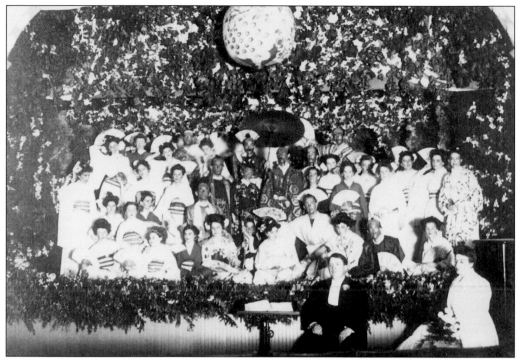

These Fishkillites were entertaining an audience at Van Wyck Hall. Local shows were produced by both residents and traveling professional troupes. Is this the *Mikado* or *Madam Butterfly?*

Built by the Sons and Daughters of Temperance around 1840, this hall stands at the corner of Broad and Robinson. Long before the days of Social Security, the Temperance Society set itself up as a benefit fraternity. Members who were ill or unable to work received a weekly stipend. The society disbanded after it had to pay out more than it took in. The Greek Revival style building was sold, and today it is a private residence with apartments.

This building was the headmaster's residence and dormitory for Dr. Pringry's Academy, an all-boys' school. It was located on Church Street, with its front facing the rear of the First Reformed Church cemetery. Later it was converted to apartments before its demolition in 1967. The site is the rear yard of Tutti Quanti Restaurant.

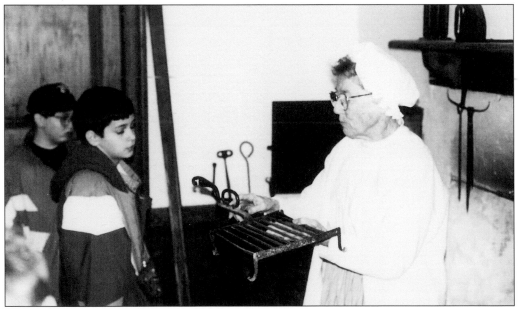

As part of the New York State Local History Curriculum requirements, students in the fourth grade tour local historical sites. Several students from Fishkill Elementary School are learning about the eighteenth century kitchen from Eileen Villforth at the Van Wyck Homestead Museum. Well over a thousand children tour this museum each school year.

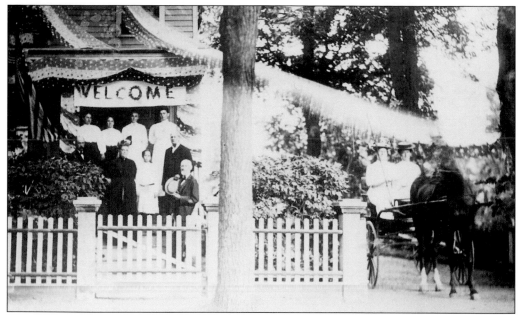

These folks are sitting on the steps and watching the firemens' parade, *c.* 1905, at the home of Dr. Howell White. From left to right: (top step) the two Misses Moshier from Fishkill Landing, and Laura and Bertha Hatchell; (second step) Joseph Dudley Jr., Mrs. Howell White, Helene (her daughter), and Alexander Dudley (of Brinckerhoff); (below) Joseph Dudley (resident of the house). Driving the carriage is Carsuella Hustis with her sister Alice, both of Brinckerhoffville.

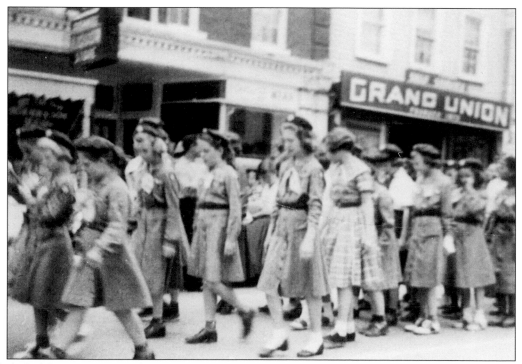

A Girl Scout troop marches west on Main Street, in the 1956 Memorial Day parade.

Varied activities and experiences await children at the Sharpe Reservation. Farm animals are there to be cared for, and sports, swimming, crafts, nature studies, and the Gustafson Planetarium are accessible for all. At Camp Pioneer, older boys learn outdoor skills. During the school year, classes from area schools are able to utilize the facilities.

New York City's disadvantaged children have enjoyed free summer vacations in the mountains of Fishkill since 1877. The Fresh Air Fund is private non-profit organization which sends busloads of children "off to the country" for several weeks at Sharp Reservation. A group of girls are shown in a tent unit known as Camp Bliss.

Catherine Eckler relaxes at the "old swimming hole" at the Brinckerhoff Bridge on July 4, 1924.

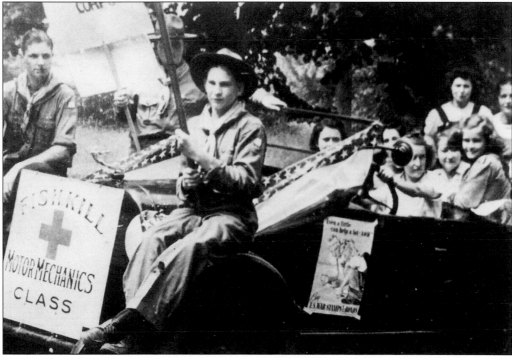

Parading in Fishkill in 1944, this group was proudly telling all that they were enrolled in the Red Cross Motor Mechanics Class. They were supporting our servicemen. In front: Bob Van Voorhis (left) and Louis Roess (right). Shirley Van Voorhis is behind the wheel.

St. Mary's parish was established in 1953. Services were held in the school until the church was dedicated in 1968 by Cardinal Terence Cooke, archbishop of New York. Membership has grown from about 100 to over 3,000.

Before St. Mary's parish was established, Mass was offered in the mission chapel of St. Mary on Bedford Street. It was built in 1863 as part of the parish of St. Joachim, Beacon. The chapel is used for meetings and special programs.

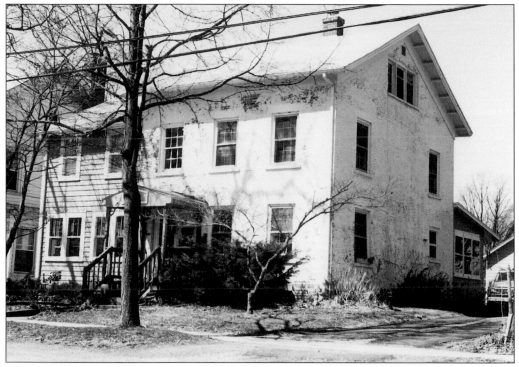

This two-story brick house at 49 Broad Street was constructed in 1858. The frame addition was built in 1932, when it was the residence of Mayor Wilson. The house was featured as part of the background for the film *Nobody's Fool*.

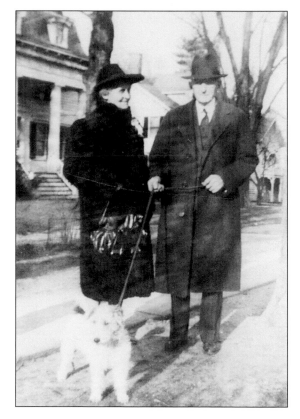

Mr. and Mrs. Edgar Shook posed for this picture with their dog, Brush. Edgar was elected assessor in 1918 and held that office for the next forty years! The Shooks were the parents of Marion Shook Post.

Students at Fishkill Elementary School pose in May 1936. Left to right: (top row) Robert Van Voorhis, Nancy Champlin, Paul Hunt, and Arthur Horton; (bottom row) Esther Barton, Leo Bower, Delores Hover, Guy Morse, and Harry Light.

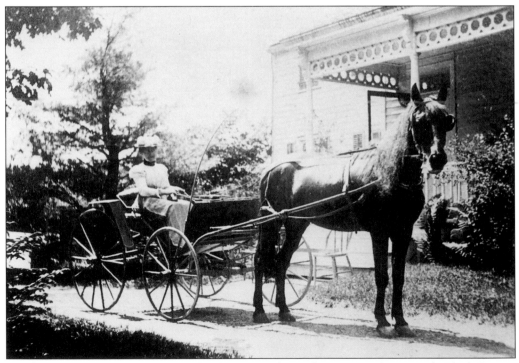

Cora Smith Storm rode in front of Sebring Smith's Jackson Street home with Black Beauty leading the carriage. Today, the house is part of Jamestown Farm Apartments.

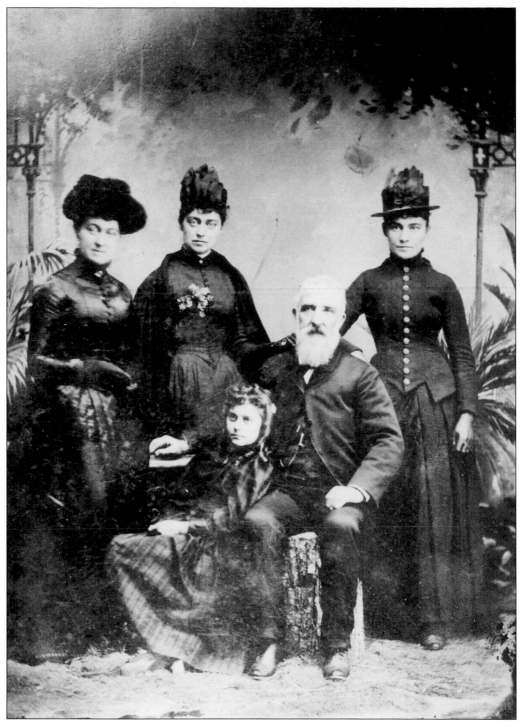

A family photograph. Standing are: Cora, Mary, and Leah Smith. Seated are: Maude Smith and Martin Cramer.

This brand new Model-T Ford was Jim Ortman's pride and joy.

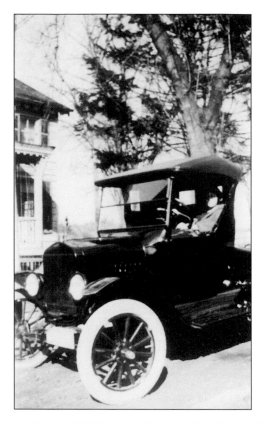

This Victorian brick home with Mansard roof and quoins at the corners stands proudly on Broad Street. It was built in the 1880s by a local businessman to please his wife, who was unhappy at having to move out of her New York City brownstone.

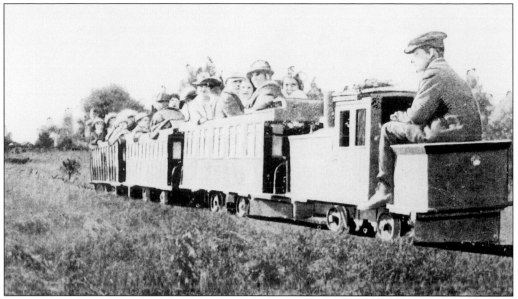

Built in 1926, The Vest-Pocket Railway on the W.C. Gage property delighted both children and adults. It ran until 1938, with a short revival in 1948.

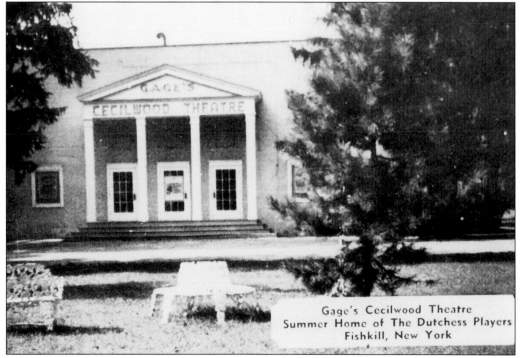

Gage's Cecilwood Theatre
Summer Home of The Dutchess Players
Fishkill, New York

This is W. Cecil Gage's Cecilwood Theater, which was a summer stock playhouse from 1948 until the late 1970s. It was demolished in 1985 and was replaced by a small office complex.

The Smith Sisters pose left to right: (standing) Cora Smith Storm and Leah Smith Jaycox; (seated) Maude Smith Shook and Mary Smith Farrell. Edward Van Kleeck Jaycox is the son of Leah. The Smith sisters were the daughters of Sebring and Alma Van Kleeck Smith.

Charles and Mary Bogardus shared their 1930s Christmas greetings on this card. Charles owned a local grocery business and both were very civic-minded. Mary was the author of *Crisis in the Catskills*. Charles was a direct descendent of Joseph and Barbara Moffat Bogardus, whose portraits hang in the Van Wyck Homestead Museum.

*W*ith the best of *H*oliday *W*ishes

Mr. and Mrs. C. Bogardus

Three

The Van Wyck Homestead Museum and Its Treasures

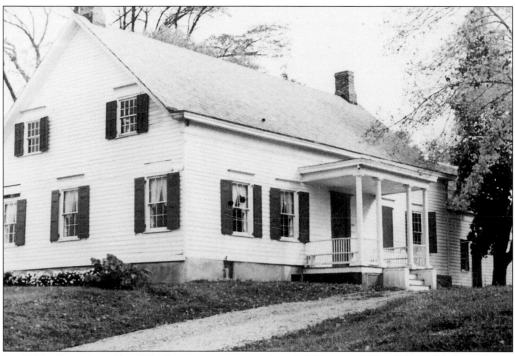

In 1732, Cornelius Van Wyck, a surveyor, purchased 959 acres of land from Madame Brett and built a three-room house. A west wing was added before 1757. The Continental Army requisitioned the house as officers' headquarters, for military trials, and the quartermaster's department, which outfitted the troops with clothing. After the war ended, the house reverted to the owners, and the Van Wyck family occupied it until the death of Sidney Van Wyck in 1882. Purchased at auction by the Hustis family, the house was later acquired by Townsend Snook. When construction of Route I-84 began, Jay and Donald Snook donated the Van Wyck House and one acre of land to the Fishkill Historical Society in memory of their father.

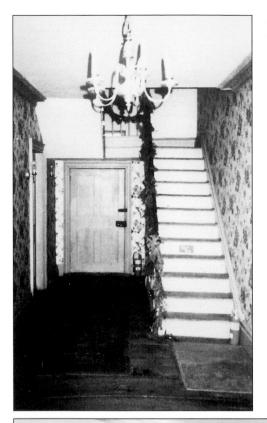

The Van Wyck Homestead is listed on the National Register of Historic Places. With a center hall with identical doors at each end, it is typical of most Dutch Colonial homes. The German silver chandelier was originally in the Hinrich house on Red Schoolhouse Road, and was given to the historical society when the house was torn down for the construction of the Fishkill Downstate Facility. The present wallpaper is a reproduction of a similar paper, removed during the 1960s restoration.

The parlor was used as a meeting room by officers in Washington's northern army, stationed in Fishkill. In renovating the Homestead after the army moved out, Isaac Van Wyck, grandson of Cornelius Van Wyck, added the Adams mantel and removed the chair rail and wainscoting. A copy of Gilbert Stuart's unfinished portrait of Washington hangs over the mantel. This room is reputed to be the location of the mock trial of the real-life Enoch Crosby, the "Harvey Birch" of James Fenimore Cooper's novel *The Spy*.

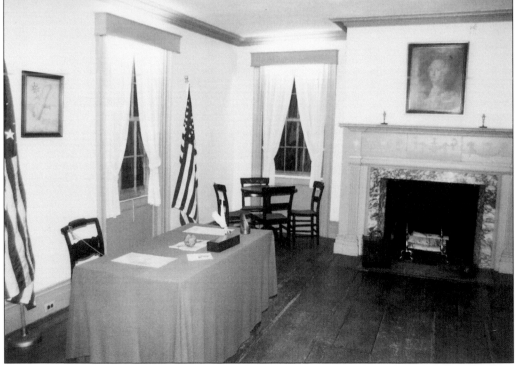

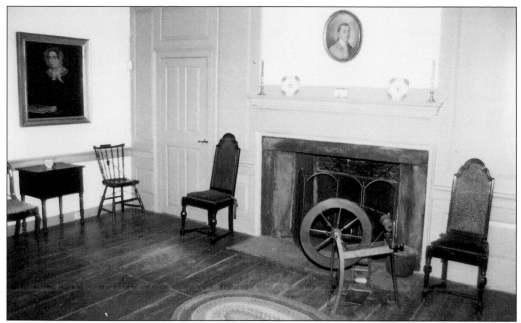

The dining room is now known as the Brinckerhoff Room, in honor of the family who provided the funds for its restoration. The mantel is original to the homestead and it is believed that the fireplace was once outlined in scenic Dutch tiles. Andrew Stockholm (1791–1855), pictured above in the pastel on velvet portrait, was the son of Phebe Brinckerhoff, daughter of Colonel Derrick Brinckerhoff.

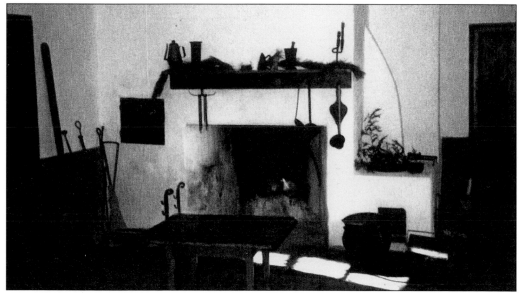

The fireplace in the kitchen of the 1732 portion of the Homestead was where all the cooking was done. The beehive oven on the left was for baking. To provide continuous hot water, a firebox (just above the floor on the right) heated water in a large kettle in the enclosure above it. The tavern table was added in the 1800s. Funds for restoration of the kitchen were provided by Adeline Horton Bailey and Elton Van Vlack Bailey Jr., direct descendants of Cornelius Van Wyck.

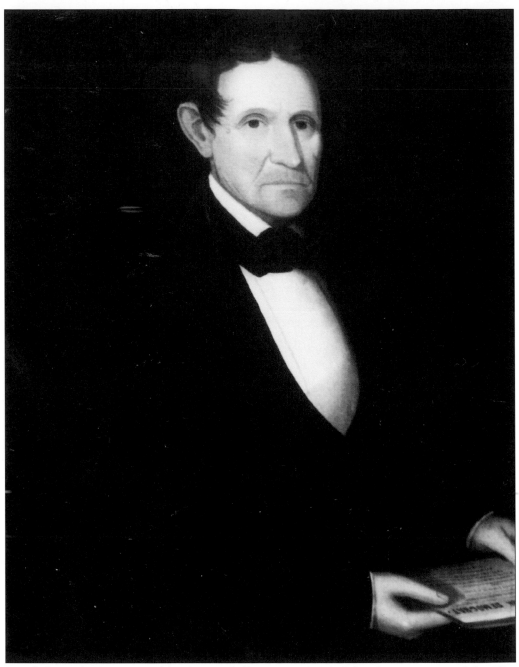

Joseph Bogardus was painted by Ammi Phillips in 1843. Mr. Bogardus, a veteran of the War of 1812, owned the Union Hotel on Main Street from early 1800s to 1840. The hotel burned down in the great Fishkill fire of 1873.

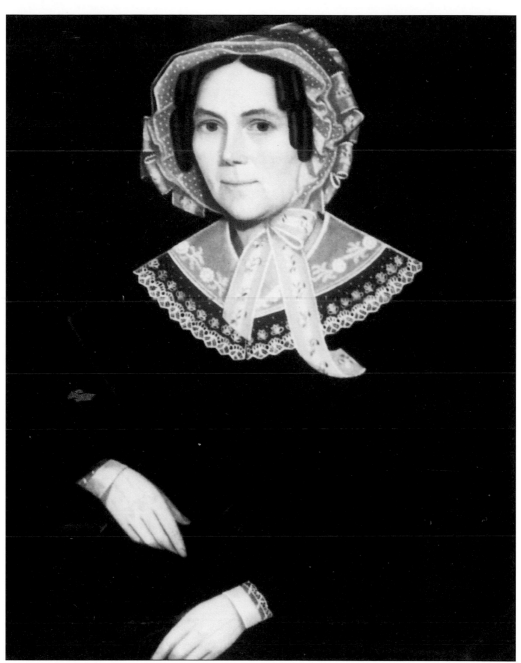

Portrait, Barbara Moffet Bogardus (wife of Joseph Bogardus), painted by Ammi Phillips, 1843. Ammi Phillips (1788–1865) was a primitive artist who traveled up and down the Hudson River Valley and border towns of Connecticut and Massachusetts, painting portraits of mostly well-to-do families.

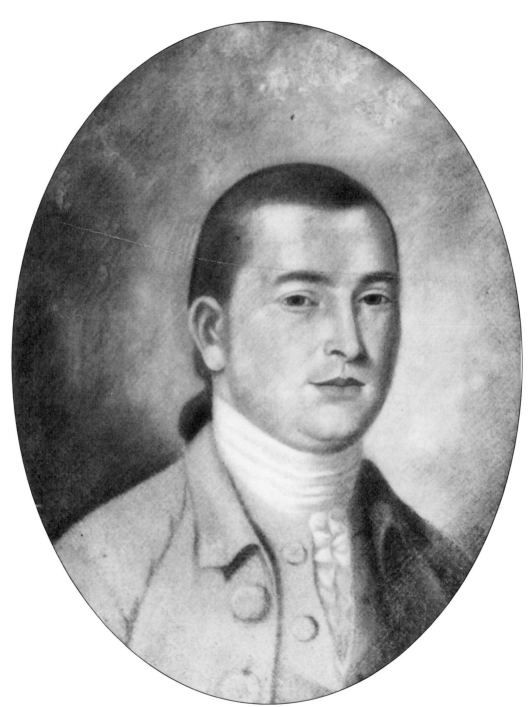

Portrait, Andrew Stockholm (1791–1855). Andrew's mother, Phebe Brinckerhoff, was the daughter of Col. Derrick Brinckerhoff.

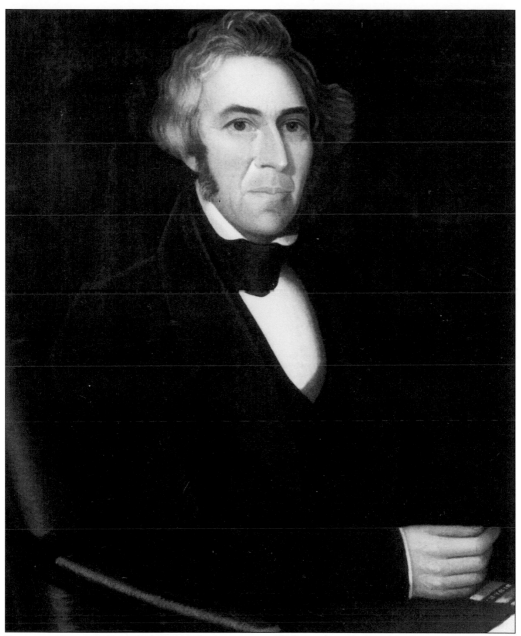

Portrait, Elias Phillips (1792–1879), by Ammi Phillips, 1843. Elias Phillips was the ninth child of John Ralph Phillips, who came from Holland. Elias married Maria Wilde. His second marriage was to Elizabeth Northrup.

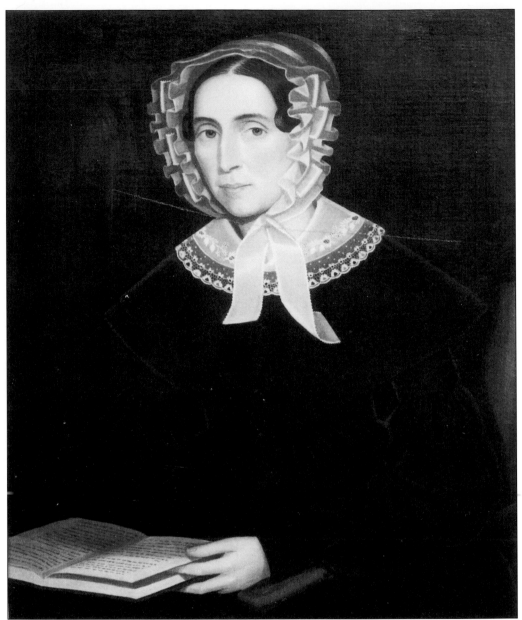

Portrait, Elizabeth Northrup Phillips, by Ammi Phillips, 1843. She was the second wife of Elias Phillips, with whom she had one son, Joseph White Phillips. This Phillips family is not related to Ammi Phillips.

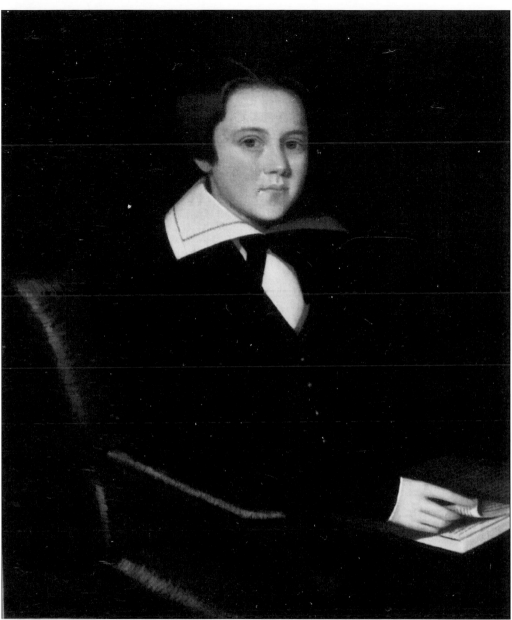

Portrait, Joseph White Phillips (1835-1906), by Ammi Phillips, 1843. Joseph was the son of Elias and Elizabeth Phillips. He was a farmer in East Fishkill until he purchased a house and land in Gayhead and went into the milk business. He rented his original acreage. About 1897, he "retired surrounded by comforts and luxuries."

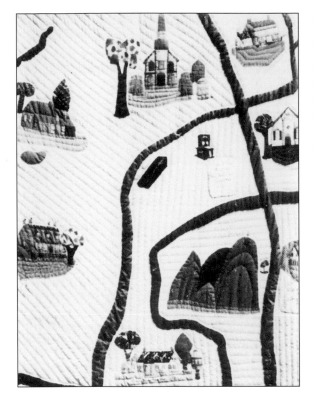

The Bicentennial Quilt, designed by Elisabeth Scardapane and executed by Patricia Eagan in 1976, depicts roads and buildings of historical significance in the area. The quilt won first place in the 1976 Eastern States Exposition. Some landmarks are: Van Wyck Homestead, Mt. Gulian, Mme. Brett Homestead, Stonykill, First Reformed Church, Trinity Episcopal Church, Brinckerhoff Manor, Hudson River, Highlands, New Windsor Cantonment, Mt. Beacon, Bailey's Forge, Fishkill Tea Party, Samuel Loudon's printing press, Purple Heart, and the N. Y. State Constitution.

This picture, embroidered in silk, was made by Aletta Van Wyck, b. 1801. She was the great-granddaughter of Cornelius Van Wyck. "Letty" embroidered the picture while a student at M.E. & A. Sketchley Boarding School in Poughkeepsie. The Greek Revival period suggested the theme. "Tancred" carved on the trunk of the tree was a nobleman who led a Crusade to the Holy Land in 1097.

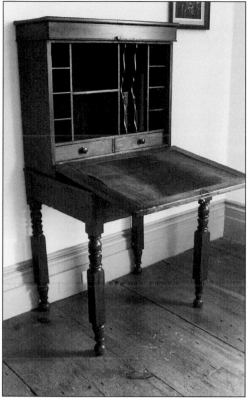

This is an eighteenth century, New York style desk with flip-down lid. It belonged to Julia Shaw Bogardus, and at one time was located in a house that was torn down for the building of the Holiday Inn.

This Windsor chair was manufactured by Meislahn & Co., Baltimore. The chair was carried in a covered wagon to Ohio in the early 1800s. It was given to the historical society in the name of Dr. Ivy Lowther Peter's father, who had been a minister in the local Methodist Church. Dr. Peter was a professor at Vassar College.

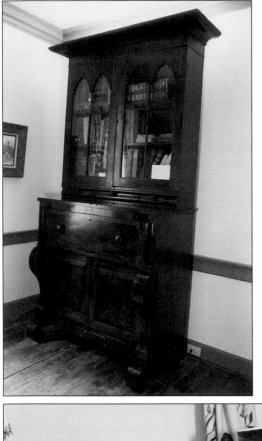

This bookcase was made in 1840 by Hyman Rosa, a cabinet and coffin maker, whose shop was located on Main Street in the village (see p. 18). It was purchased for $55 by General Abraham Van Wyck for his son James.

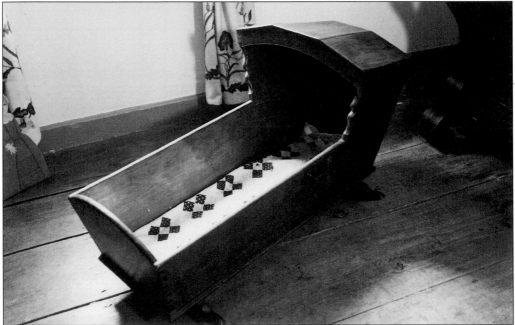

This late-1700s hooded cradle is typical of the Hudson River Valley Dutch style. It was purchased by General Abraham Van Wyck for his son James and has, until recently, been used by generations of the Van Wyck family.

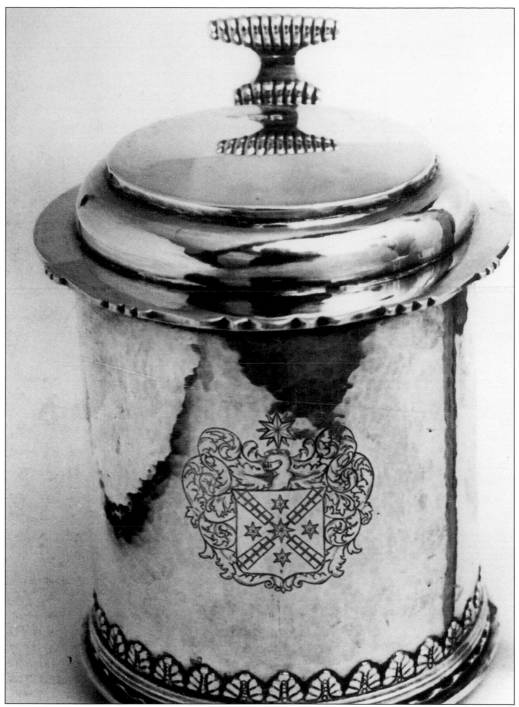

Made for Richard Thorne, this silver tankard is signed by Jacob Boelen, *c.* 1685. Thorne was grandfather of Hannah Thorne who married Cornelius Van Wyck in 1717. This tankard was part of Hannah's dowry, and it was brought up to Fishkill in 1732. The Thorne coat of arms appears on the front. The tankard is now in the Brooklyn Museum, given in memory of Richard Van Wyck Jr.

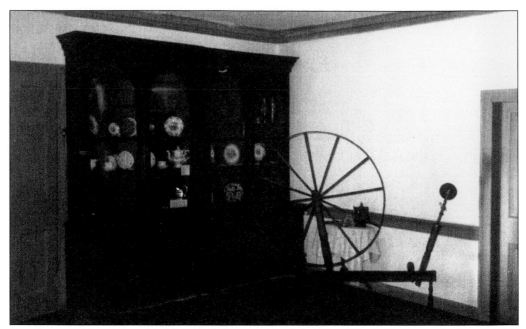

Standing in what was probably the dining room of the Van Wyck Homestead, this c. 1850 bookcase from the Derrick Brinckerhoff house contains some of the china and silverware in the museum's collection. The spinning wheel is known as a "walking wheel," because the person using it would walk back and forth to wind the yarn.

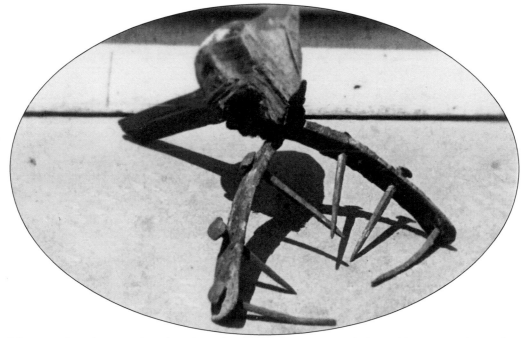

This is a claw that was found in the Whipping Tree. It was said that soldiers were clamped to the tree when receiving lashes as punishment. Lafayette wanted the number of lashes reduced to fifty. George Washington agreed, but the initial punishment was to be followed by fifty more lashes, several days later.

This is the Whipping Tree, named during the Revolutionary War because soldiers were tied to the tree when punished. The walnut tree was located in front of the Van Wyck Homestead. After the tree blew down in a windstorm in 1898, people gathered pieces to make useful objects for the home and as souvenirs. The Van Wyck Homestead Museum owns a gavel box and a tabletop made from its wood.

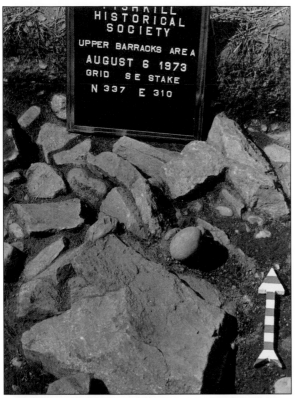

The arrow on this grid from an archeological dig always points north. This dig was on the Raiche property and shows the fallout from a barrack's chimney. Barracks were located in several places, including the area near the mile marker sign "66 miles to N. York," situated at the present-day entrance to Dutchess Mall.

Extensive digs took place on the Van Wyck Homestead property during the 1960s restoration. Members of the historical society and others in the community spent many hours digging in the dirt. They rejoiced upon finding a musket ball, shard of pottery, broken knife, or a button from a uniform. New York State archaeologist Jeff Olsen was sent to supervise and extend the dig area when foundations were uncovered as Route 84 advanced. Later digs were conducted under the supervision of Temple University.

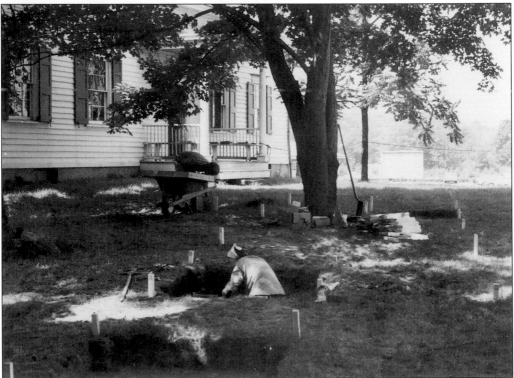

This attractive bottle was a 1975 fund-raiser for the restoration project of the Van Wyck Homestead. It was commissioned for sale by the Fishkill Historical Society in order to save the Van Wyck house from demolition by the New York State Highway Department. The Society eventually got the State to agree to move the house, but in the end it was decided to let the house remain on the original site.

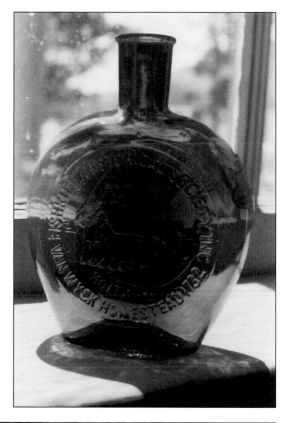

This is the house of Cornelius C. Van Wyck, son of Cornelius Van Wyck, who settled in Fishkill in 1732. In the late 1820s, the property was known as the Shaw Farm, later owned by Henry Raische Sr. The house was torn down in 1965 for the construction of the Holiday Inn.

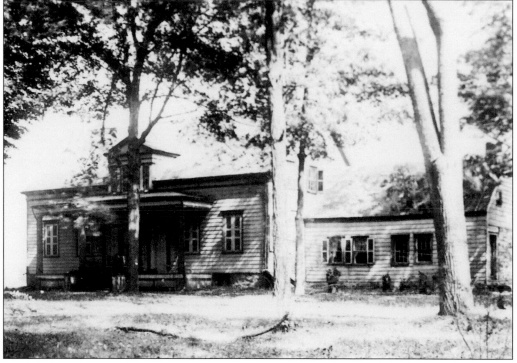

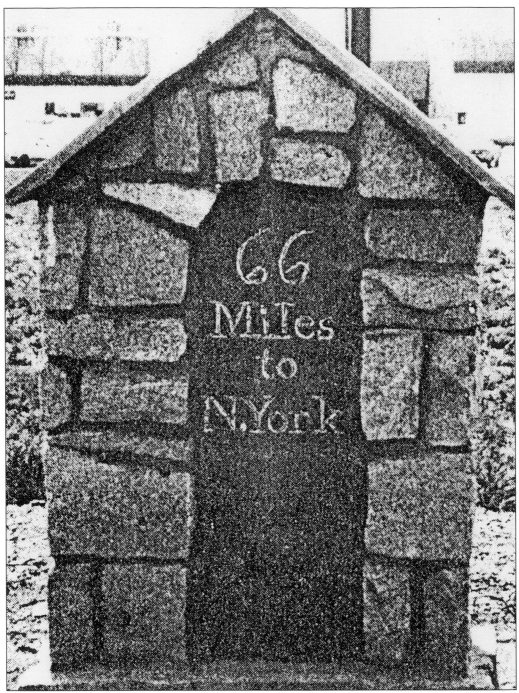

Sometime at the end of the eighteenth century, mile markers were placed one mile apart along the Albany Post Road between New York City and Albany for the benefit of travelers and post riders. The cost of a letter was determined by the distance traveled. There were no postage stamps, and the recipient of the letter paid the postage. This mile marker is at the entrance to Dutchess Mall. The New York State DOT placed the protective stones round the milestone for reinforcement.

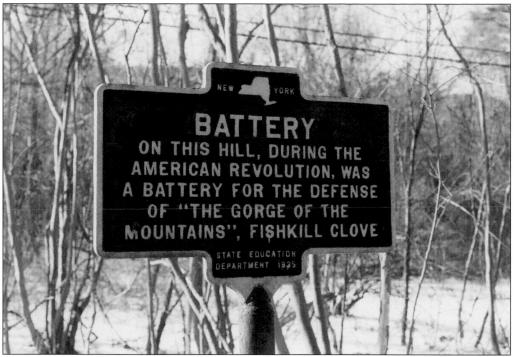

This sign stands at the site where an American battery defended the "gorge of the mountains" at Fishkill Clove during the Revolutionary War. It is located on the current Route 9 (the Albany Post Road), south of the village.

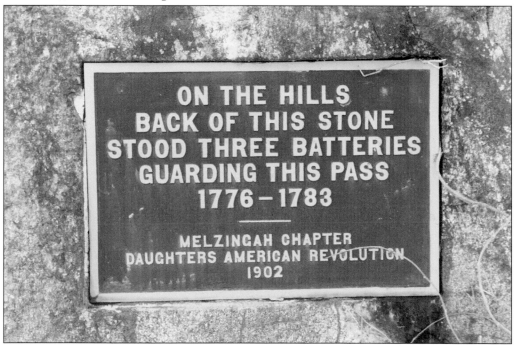

Along Route 9 near the Wiccopee Pass stands this stone, put up by The Malzingah Chapter of the Daughters of the American Revolution. The hills are part of the Highlands.

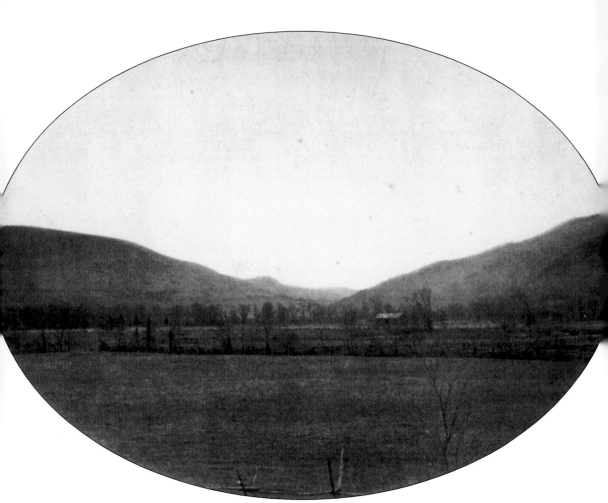

Looking south through the Wiccopee Gap, toward current Putnam County, one sees an excellent view of the Highlands of many years ago. In the foreground is the site of Dutchess Mall, which extends for some distance along Route 9.

Four

Living and Working in Fishkill

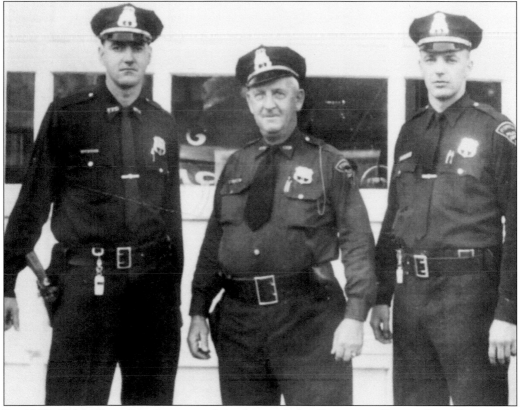

In 1965, Fishkill's police force posed in front of the Protection Engine Fire Company's headquarters. Pictured are: Patrolman Glen R. Scofield, Chief Benjamin G. Puff, and Patrolman Donald F. Williams. The last is currently chief of the Town of Fishkill Police force. To most schoolchildren, Ben Puff *was* the police force. He could be found daily, guiding the children across Main Street as they went to and from the Fishkill Elementary. Chief Puff served on the police force from 1957–1972. His shining hour came in the late 1950s, when he single-handedly apprehended two escaped prisoners from the correctional facility, down near the railroad tracks behind the present Barkers Department Store.

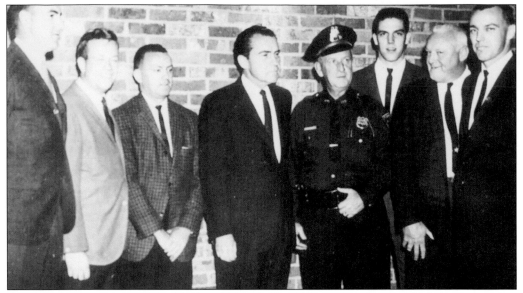

On a campaign trip trough Fishkill in 1968, Richard Nixon dined in the Holiday Inn with a group of police officers. Pictured are: Glen Scofield, Larry Newcomb, Richard Price, President Nixon, Chief Ben Puff, Richard Williams, Homer Cox, and Donald F. Williams.

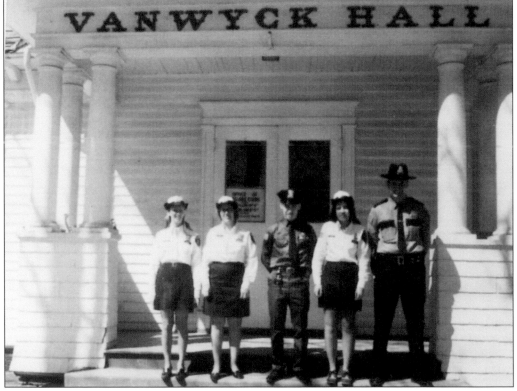

A group of police cadets with Officer Bill Dicket, after completing a training session. They are Anne Ficker Bettina, Rene Robinson, Richard Robinson, and Sue LaDue Elwood. This photograph was taken in 1972 in front of Van Wyck Hall.

Mayor Sarah Taylor was in office for ten years, from 1965 to 1975. She was especially interested in youth programs. Here she is observing part of the Police Cadet training program. Officer Bob Bentivegna is instructing Cadet Steve Minard at the firing range.

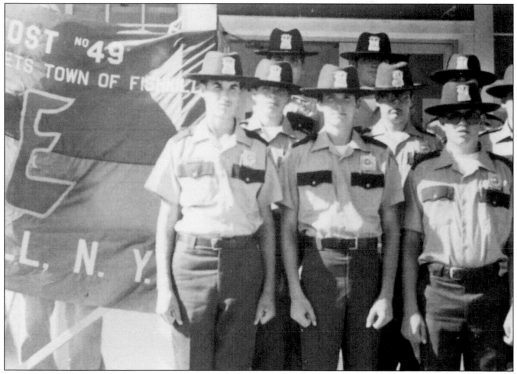

A group of police cadets, Post 49 from the Town of Fishkill, pose in front of Van Wyck Hall in 1980. In the front row are: Donald F. Williams Jr., Scott Bierce, and Mark Penny.

The Village Police conducted a Memorial service in front of Van Wyck Hall in 1985 for their late chief, Joe Serra. Attending were: Chief James Hodgins, Officer Nick Marrone, Mrs. Serra, Officers G. Adams, Trudy Newman, Vincent Guarino, Charles Secore, Al DiTomasso, Lt. Robert Hughes, Officer G. Herrmann, and Gary Behans.

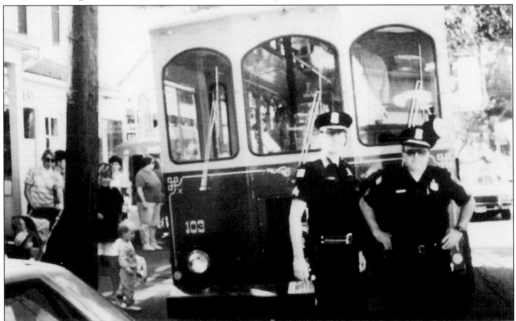

In September 1993, the Village of Fishkill introduced a Main Street Craft Fair. It was very popular and a beautiful day contributed to the festivities. The trolley, which rode people around the village, was very popular. Sergeants Robert Bessman and George Herrmann were on traffic detail.

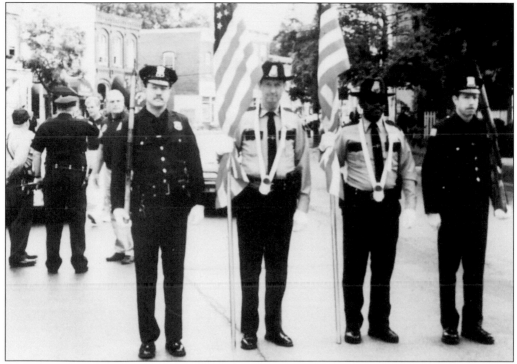

Community Day is a big event each September. Residents of the village and town get together after a parade in Geering Park to picnic, play games, and share crafts and ideas. The color guard members are: Village Officer David Sanzo, Town Officers Bob Hughes and Charles McKinny, and Village Officer Jon Hooper.

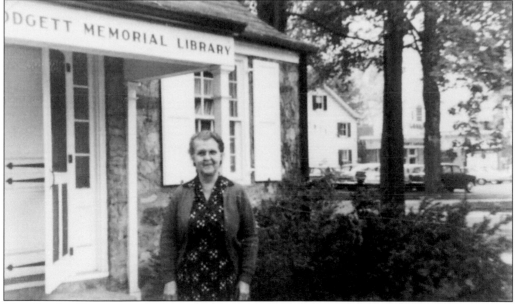

Mrs. Bertha Hauptmann, library director for eighteen years, stands outside of the original public library in Fishkill, which opened in 1934. The late Mayor Sarah Taylor was the first library director.

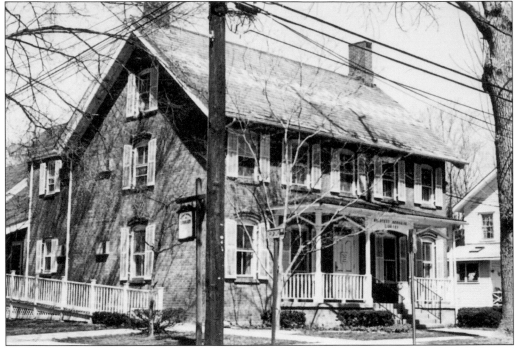

A two-story brick house on Broad Street at the corner of Bedford Avenue was purchased in 1975 for $40,000 from the owner Mrs. Olivia Verne, to allow for an enlarged library facility.

Just nine years later the library had outgrown the building purchased in 1975. A two-story addition was added to the back of the original building, giving the public more work areas, a historical collection room, and expanded shelf space.

Mayor Sarah Taylor was a "take charge" person. She was involved in all village departments and decisions during her ten years in office from 1965 to 1975. She is shown discussing planning board business with John Dow.

Protection Engine Company is showing off their Button Engine in 1905, before a parade. The engine is hitched to a team of horses. They are posing in front of the Fishkill Savings Institute. The Fishkill Inn can be seen on the left.

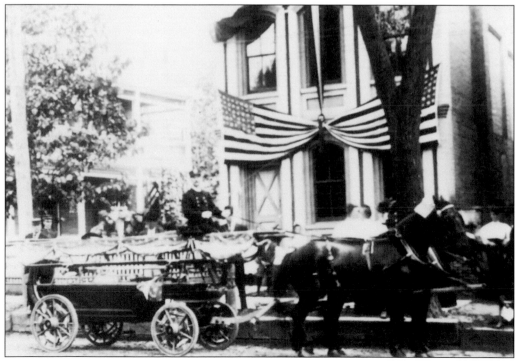

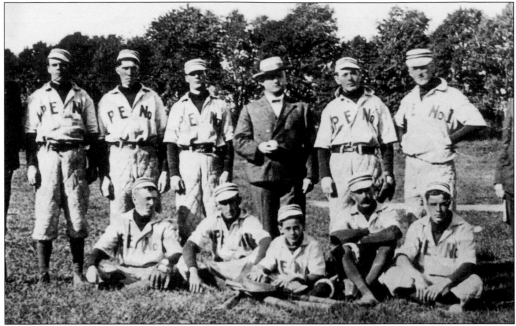

In 1905, Protection Engine Company sponsored this baseball club. Maurice F. Savage (in the business suit) was the manager. We are unable to identify any team members. Perhaps you will recognize a familiar face.

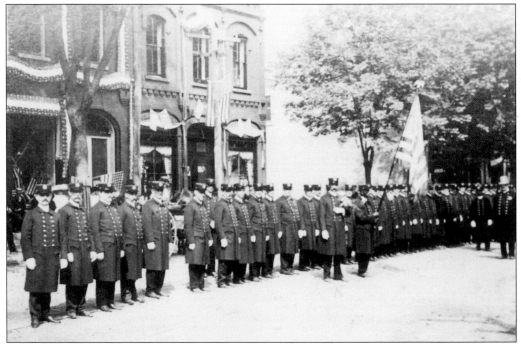

County Treasurer Captain William Haubennestal presented a new silk American flag, fringed in gold, to Protection Engine Company before a September 1906 parade. The men are lined up on Main Street near the corner of North Street, for the presentation. The flag was proudly carried for many years in parades.

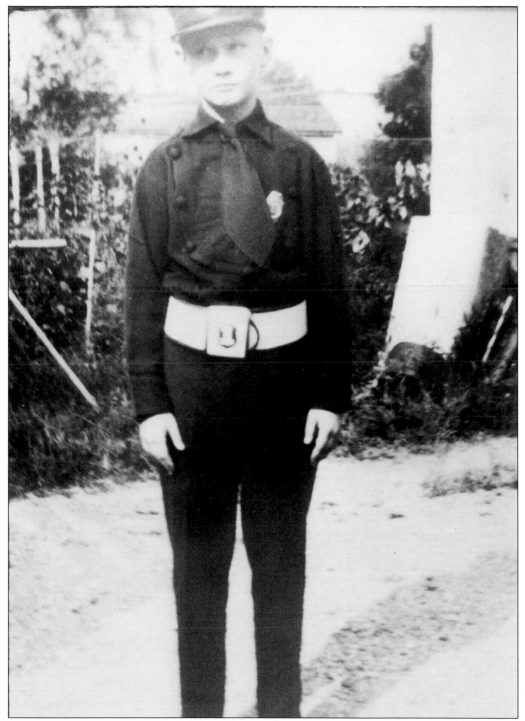

The teenage sons of members were given the honor of carrying the Fire Company banner during parades back in 1929. James Trueman Urquhart is dressed in a Protection Engine Company No. 1 uniform, in which he marched in Beacon with the firemen in September of 1929.

This Robinson Street firehouse was the third home for the fire truck. A larger facility was needed each time new and larger apparatus was purchased. The engine door has now been replaced with a bow-window and the structure is a private business.

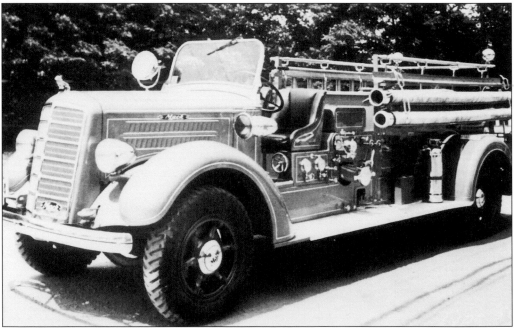

As the village grew, so grew the size of the fire company's membership and the size and complexity of the equipment. In 1937, this Mack Junior fire apparatus was purchased. It remained in service until 1966.

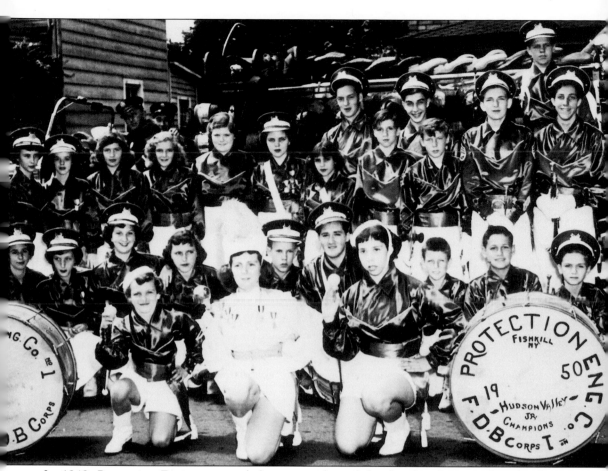

In 1948, Protection Engine assumed the sponsorship of this band and renamed it for the fire company. It was previously known as the Daniel Dugan Drum Corps. In 1950, the band members were named Dutchess County champions. Members were: (first row, between drums) Doris Gilhooly, Carol Smith, Janis Angele; (second row) Bea Bialko, Patricia Langdon, Barbara Puff, Mae Puff, Howard McClaren, Al Carozza, Al Quirk, George Zyack, and Ronald Langdon; (third row) Ellen Bialko, Jesse Bialko, Rita Sagner, Dixie Light, Carol Brooker, Shirley Smith, Bonnie Light, Arthur Lasher, and Ronnie Woison; (fourth row, with hats on, near engine) Ken Scofield, Dennis Light, Jack Gilhooly, unknown, Chet Smith (with uniform); (fifth row) Ed Straley. Firemen in the engine are Bill Hustis and Jim Adriance.

Santa and his helpers leave the current firehouse, built in 1941, to wish a merry Christmas to the residents of the village.

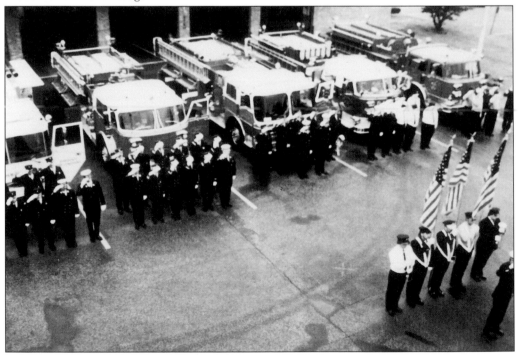

Fire companies of both the Town and Village of Fishkill participate in a chief's inspection in front of the Rombout Headquarters in 1993. The companies are: Rombout, Glenham, Protection Engine, Dutchess Junction, and Chelsea.

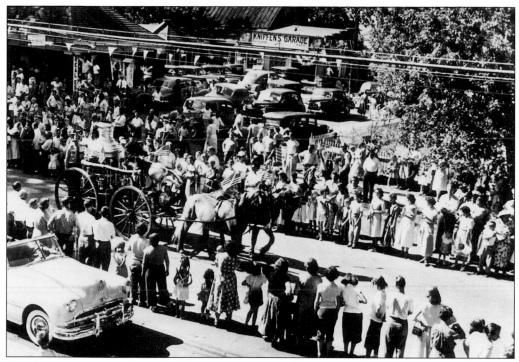

Parades are big events in small villages. A large crowd has gathered to watch this parade in July 1949. It was a Dutchess County Volunteer Fireman's Parade, always a big crowd pleaser. They are passing in front of the Protection Engine firehouse.

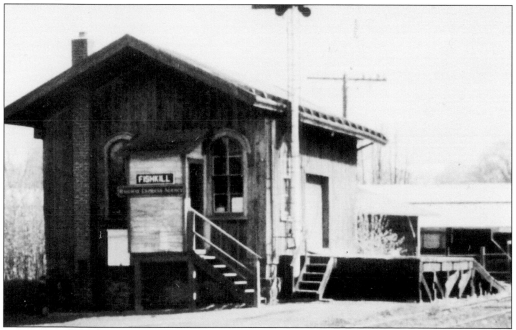

Several small manufacturing companies were in Fishkill Village following the arrival of the railroad. This freight office was located near the tracks off Route 9, where Montfort Block is today. A canning factory, cider plant, and a bag factory were in this area.

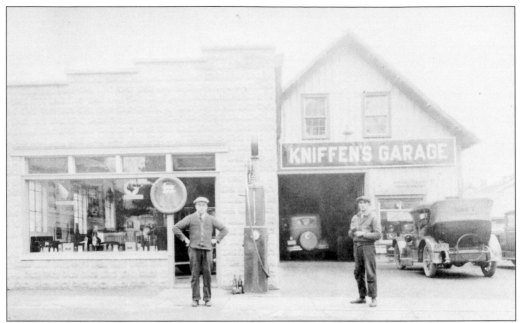

In 1936, Kniffen Garage was a busy place. Located just one block from the Main Street, in the center of the village on Church Street, Mr. Herbert D. Kniffen and his mechanic, Harry Light, were always ready to serve the driving and riding public.

Halsey F. Walcott was a well-known businessman in Fishkill in the mid-1800s. He married Jane Bogardus, whose father owned and operated the Union Hotel. The hotel was destroyed in the fire of 1873. Mr. Walcott and Mr. Benjamin had a large hardware and farm tool business on the north side of Main Street.

The Dean family enterprises in Fishkill, including a dry goods store, a weekly newspaper, and a monument business, enjoyed a long and prosperous life. Advertising didn't hurt either. This obscure 1903 church publication carried ads for many businessmen in Fishkill.

This small grocery store predates the Grand Union Store which occupied this same location in later years. Unfortunately, we are unable to identify any of the gentlemen employed in this store.

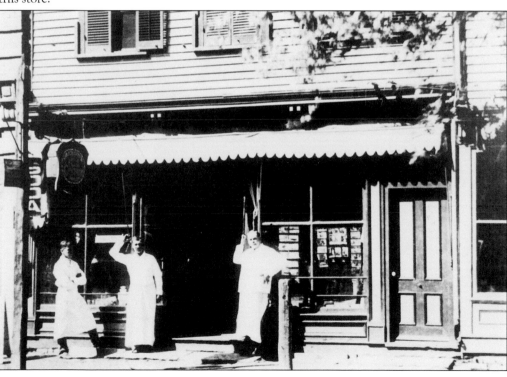

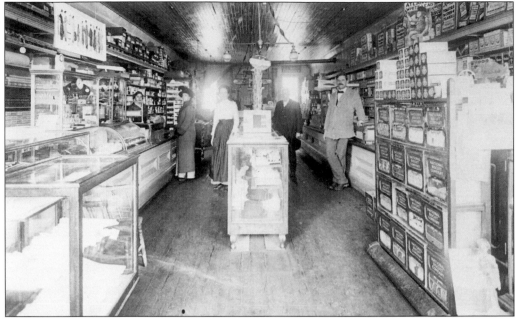

Ezra Ketcham operated this variety store in what his son called the "red corner store." He probably was referring to the store on the corner of North Street, which appeared to be painted red.

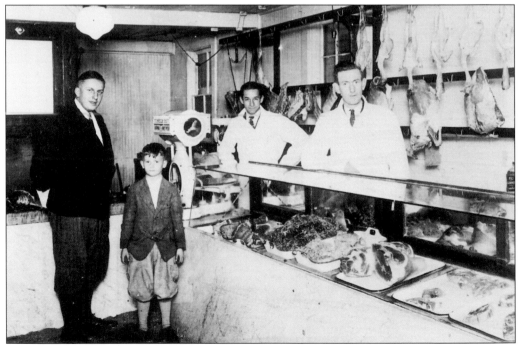

This meat market opened in Fishkill in 1926. Standing behind the counter on the right is Jasper Urquhart, the manager. He is joined by Michael Zeyak, store clerk. In front, Norman Herge, son of the First Reformed Church minister, stops in for a chat. James Trueman Urquhart is the young boy standing in front of the counter.

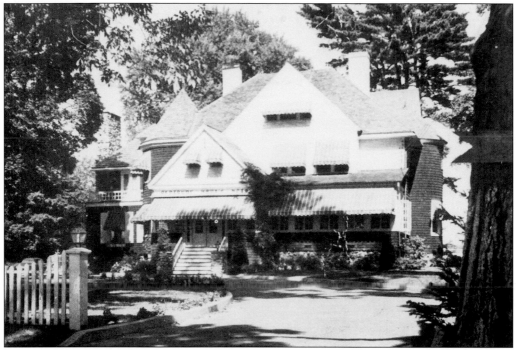

Gertrude Hart's Hotel was known for its Black Angus Bar. Later known as the Kent House, it stood on Old Main Street. The building had white clapboards with green shingle accents on the two rounded ends of the hotel. The Fishkill National Bank foreclosed on the business and restauranteur Nick Beni bought it from the bank in 1964 for $45,000. The building burned beyond repair on January 4, 1965.

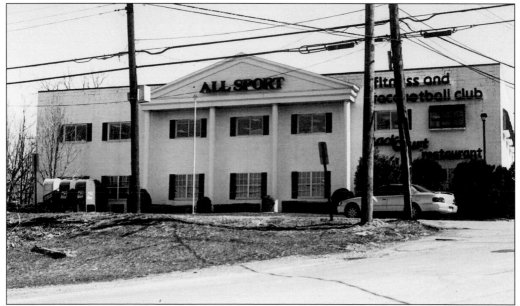

All Sport built a large complex on the site of the Gertrude Hart Hotel. It covers a much larger area than the hotel did, as tennis courts and a large parking lot extend far in back of the building.

George R. Shaw, a native of Dutchess County, was born in 1822. A prosperous farmer, he lived and worked on the family farm in what is now East Fishkill, before purchasing a 200-acre farm in Washingtonville. In 1882, he sold the farm in Orange County and purchased a farm in the Wiccopee Pass area on the Albany Post Road. It was part of the land purchased by Cornelius Van Wyck from Madame Brett. Mr. Shaw's daughter, Amy, was a teacher in the Union Free School in the Village of Fishkill.

Arvis Haight was born in Phillipstown in 1819. He worked in New York City as a salesman for nine years before returning to the mid-Hudson Valley. The farm he purchased in 1880 on Old Grange Road contained 80 acres of cultivated land and 20 acres of uncleared woodland. He kept between ten and fifteen cows and raised fruit and vegetable crops.

Mrs. Phoebe Haight (née Hustis) raised three children on the farm; Bessie Beulah, Ralph, and Edna. Edna died at age eight. Mrs. Mildred Ortman, a lifelong Fishkill resident, was a granddaughter.

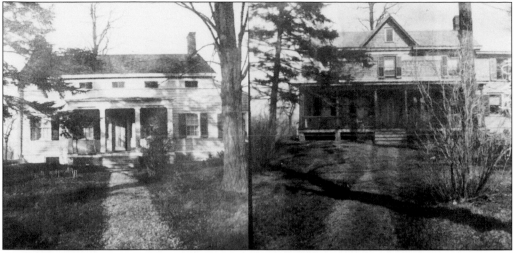

Arvis Haight and his wife, Phoebe A. Hustis, lived on a large farm on Old Grange Road, east of Fishkill. It was a combination dairy and horticultural farm. The farmhouse is shown about the time Arvis purchased the 100-acre farm in 1880. The second picture shows the house after undergoing extensive renovations in the early twentieth century.

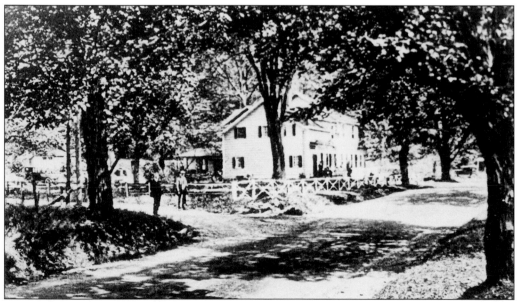

Moogs Farm has been on the King's Highway (Route 9) since pre-Revolutionary days. It is situated at the northern gateway to the Wiccopee Pass. The inn has always had a "box seat" at historical events, as it faces the road. This was also a stagecoach stop.

This was the last cow on Osborn Hill. Fern Skinner and Bradley Lybolt are with Betsy, a Holstein owned by Frank Osterc, a well driller. Frank drilled a well for a farmer who couldn't pay for the job, so he paid off the debt by swapping for a fine milking Holstein. Betsy gave the Osterc family a steady supply of milk for the next fifteen years and was a spectator at children's ball games in the barnyard all year long.

Hauling in the hay on the Osterc Farm on Osborn Hill in 1944. The two farm workers shown here were sent by the U.S. Government to relieve the labor shortage on farms during World War II. Here the fresh hay is being spread in the loft. It was not baled. After the hay was cut, the faster it dried, the better. Rain would spoil a crop of hay if it was left in a field, thus the expression, "Make hay while the sun shines."

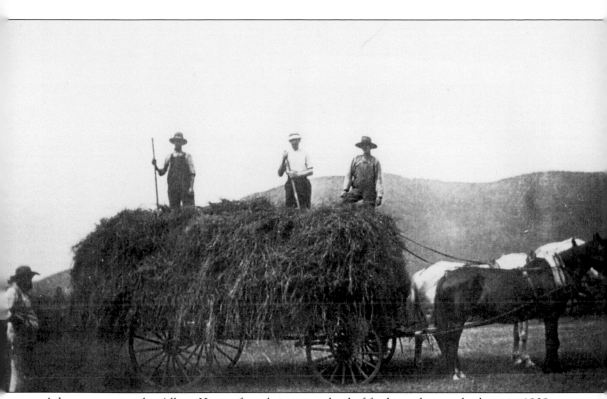

A hay wagon on the Albert Knapp farm brings in a load of fresh-cut hay to the barn in 1909. This farm was located on the Moog farm site. Mr. Knapp is aided by William Bastian and two hired farmhands.

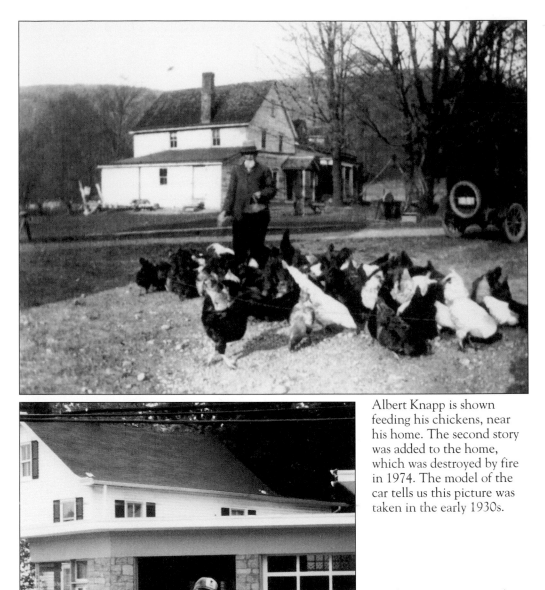

Albert Knapp is shown feeding his chickens, near his home. The second story was added to the home, which was destroyed by fire in 1974. The model of the car tells us this picture was taken in the early 1930s.

Neither rain nor snow, sleet nor hail have stopped Roger Perry from delivering our mail. In October of 1996, Roger will have driven or walked the streets of the village for thirty-five years, averaging 2,530 miles per year. That means Roger has traveled the distance around the earth at the equator three and one half times since becoming a postal employee.

Five

Fishkill's Neighbors

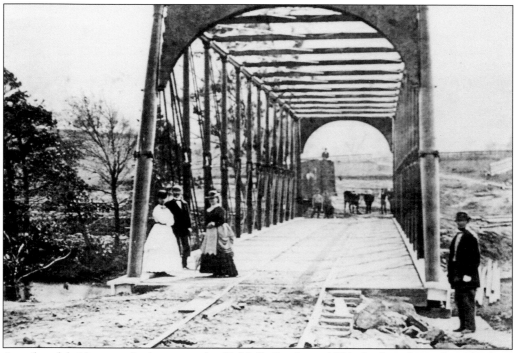

A railroad bridge was built across the Fishkill Creek in 1871, leading from the Glenham railroad station into the Glenham Mill Company property. Carloads of coal for fuel could then be brought right into the mill. A formal completion photograph was taken by Slee Brothers, photographers in Poughkeepsie, in 1871, and shows a team of oxen pulling the first railroad car across the bridge. Standing on the bridge are: J.D. Fouquet (the civil engineer who designed it) and his wife, Mrs. S.W. Whipple; the wife of one of the contractors (the other contractor was R. Comins); and John F. Gerow (who did the masonry work).

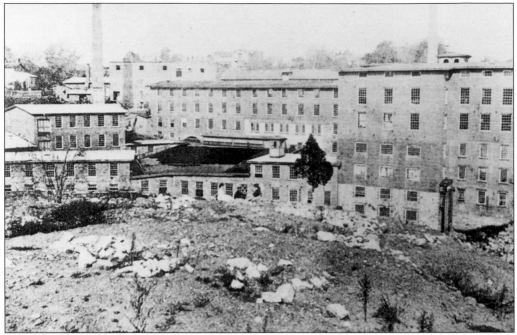

These mill buildings were built just in time to capitalize on the Union's need for blue serge cloth uniforms for the expanding Civil War Army. The buildings were abandoned by the turn of the century and were either taken down or remodeled when the Texaco Research Laboratories located on the site in 1930. To this day, Texaco draws fifteen percent of its power from the rapidly flowing Fishkill Creek.

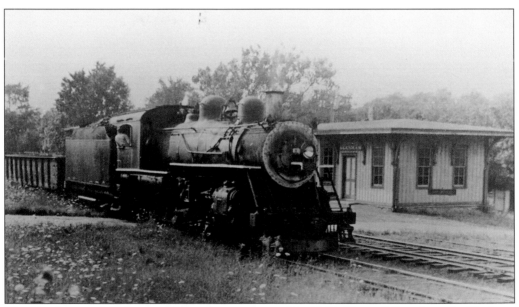

The Dutchess and Columbia Railroad was organized in 1866. The rail line through Glenham was completed in 1868. This small community had separate stations, one for passengers and one for freight, until the popularity of automobiles put the passenger trains out of business.

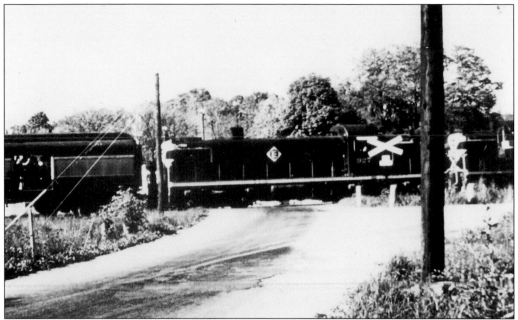

This train is passing over the tracks behind the Texaco Research Center in 1965. Washington Avenue was often closed several times a day, as hundreds of cars lumbered across, along the rails.

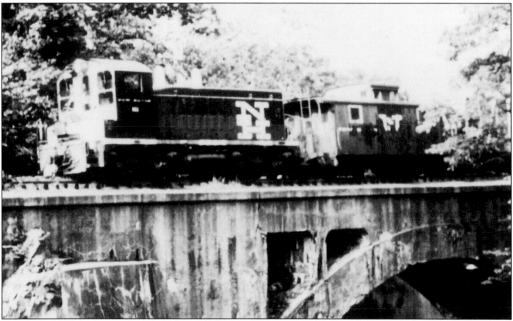

The Erie Railroad train is passing over the trestle in 1968 as it heads west. Business remained brisk along the tracks until the late 1980s. A spur of the railroad went right into the mill in 1871, and in 1971, Texaco Research Center was using the same rail line to transport products to market.

This is the 1920 fourth grade class in the Glenham Union Free School. Their teacher was Miss Helen Keating. In the mid-1950s, Miss Keating returned as Mrs. McGurk and had many children in her classes who were the offspring of previous students. Left to right: (top row) Hazel Hirst, Wellington Wolfe, Jacob Kacur, Elsie Kohrhamer, James Burke, Harry Magee, and Grace

Murphy; (second row from top) Anna Urbanjak, Theresa Caspary, Mary Baca, Edward Murphy, Harry Whitcher, Albert Belle Isle, and Elizabeth Conrad; (bottom row) Lawrence Hancock, Gertrude Flynn, Andrew Urbanjak, unknown, William Burke, Joseph Lucy and Harold Wolfe.

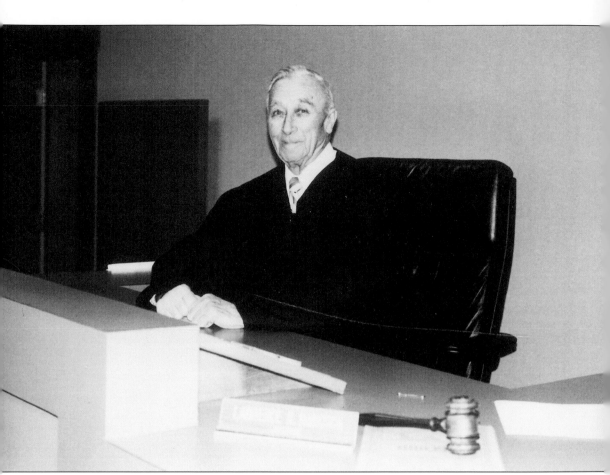

Judge Lawrence Hancock, at age eighty-five, is the longest-tenured judge in New York State. A lifelong resident of Glenham, he conducted his first court sessions from his mother's kitchen table in 1937, receiving five dollars per case. A student in the Glenham Union Free School, he has never forgotten his humble roots. Judge Hancock was the first president of the Fishkill Historical Society when it was organized in 1962. He is still a very active member.

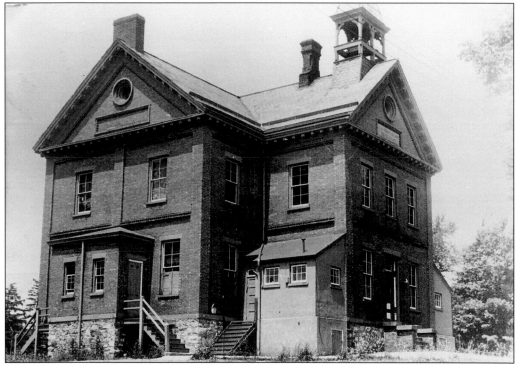

Glenham, N. Y. Oct 11 1884

Mr. Mark Brierley

To **School District No. 3, Town of Fishkill,** Dr.

For School Tax, - - - - - - $ 0 84

For Commission, - - - - - -

Received Payment, *Chas H Mase* Treasurer.

We would all be thrilled to have a school tax bill like this. In 1884, Mark Brierley received his tax bill for the Glenham Union Free School, District 3, totaling 84¢.

The Glenham Free Union School District was organized in 1866. This four-classroom building, with two classes per room, opened in 1872. It closed in 1956 when a new school was built. This building was sold to Texaco and taken down to extend the parking lot.

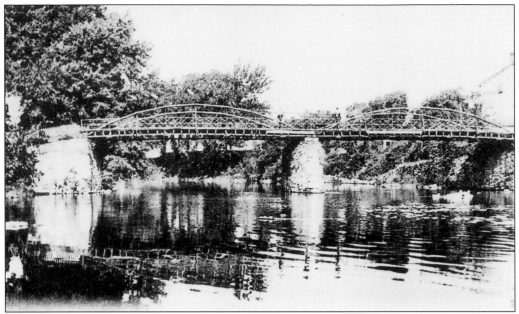

Passenger cars used this bridge over the Fishkill Creek. The creek that flows beneath the bridge was the power source for the mills. It drops nearly two hundred feet over slate and limestone ledge between Fishkill and the Hudson River, tumbling over nine dams.

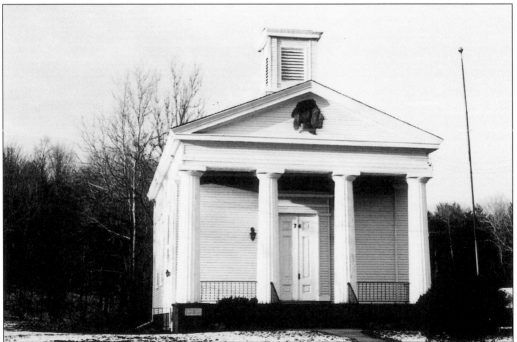

Starting in 1838, the former Glenham Reformed Church used this building for weekly church services for over 100 years. In the late 1940s, membership declined and Texaco requested to buy the property. In 1951, a new building was built across the road using as much of the materials from the original church as possible. In 1980, the Mawenawasigh Tribe of Red Men made the former church their home. The structure is now up for sale.

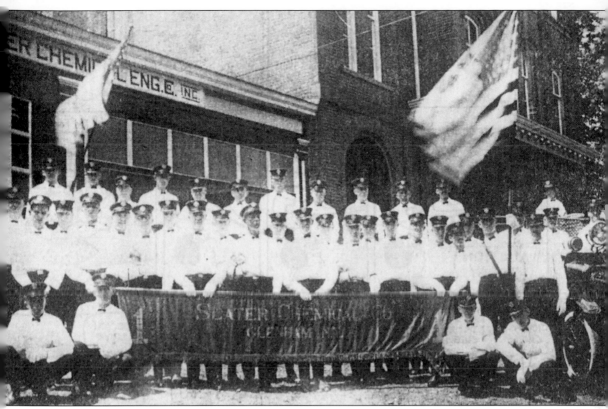

Slater Chemical Company members stand proudly with their first fire fighting apparatus, a Model-T Ford chemical fire truck which they purchased in 1921. The fire company was named in the honor of Jesse Slater, a Glenham resident who lost his life in World War I. The year 1996 marks the seventy-fifth anniversary of this company.

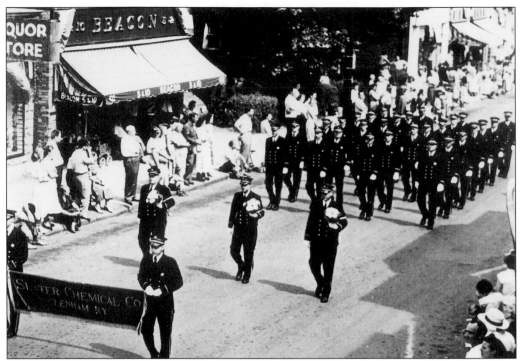

Glenham's Slater Chemical Fire Company is pictured marching in the Dutchess County Annual Convention Parade in Beacon, July 1951.

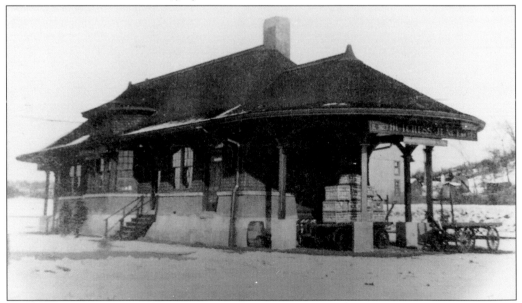

Dutchess Junction was a small, quiet community which suddenly became a busy railroad junction. It was the site of half a dozen brickyards which flourished between the 1840s and 1930. The Newburgh, Dutchess, and Connecticut Railroad intersected with the Hudson River Railroad at this location. The railroad station and much of the railroad tracks have disappeared, but Dutchess Junction continues to thrive as a bedroom community with a wonderful view of the Hudson River.

Francis Timoney was the owner of four brickyards between Verplanck Point and Brockway. He built the Roman Catholic Church in an area of Dutchess Junction he called Timoneyville. The church was named St. Francis in honor of his patron saint. The Timoney family continued production and the sale of bricks into the 1930s. They marketed 220,000 per day.

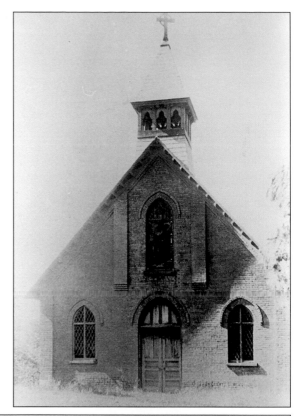

Dutchess Junction was 1.6 miles below Fishkill Landing and in the midst of extensive brickyards. The hamlet built this school upon the hill to educate the children of the brickyard and rail employees. The school closed in 1956 and the building has been converted to a private home.

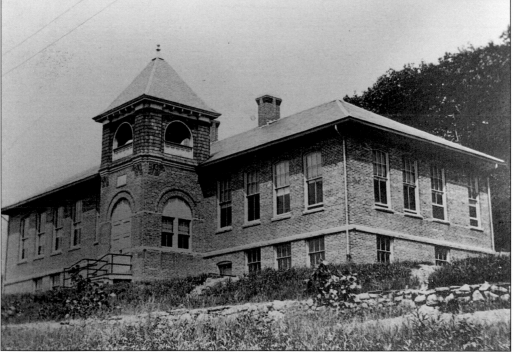

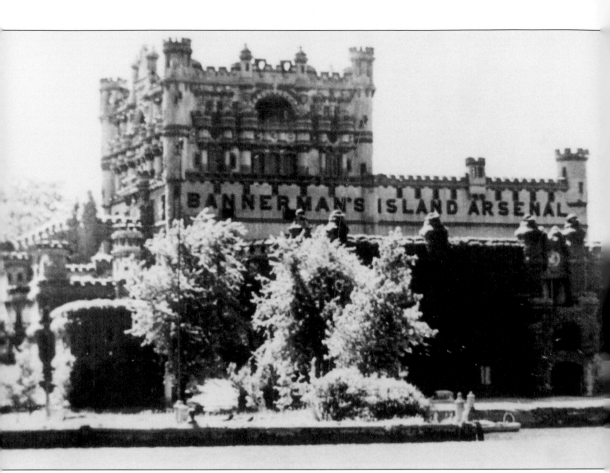

Looking eastward, residents of Dutchess Junction see Mount Beacon, and to the west, not far from the shore, one views Pollepel Island with its imposing Bannerman's Castle. The island, originally owned by William Van Wyck of Fishkill, was used during the Revolution to help defend the Hudson Highlands from advancing British Troops. Bannerman's Castle was begun c. 1900 and completed by 1908 by Francis Bannerman, who was looking for a storage facility for his stock of surplus military equipment and for a Scottish castle summer home for his family.

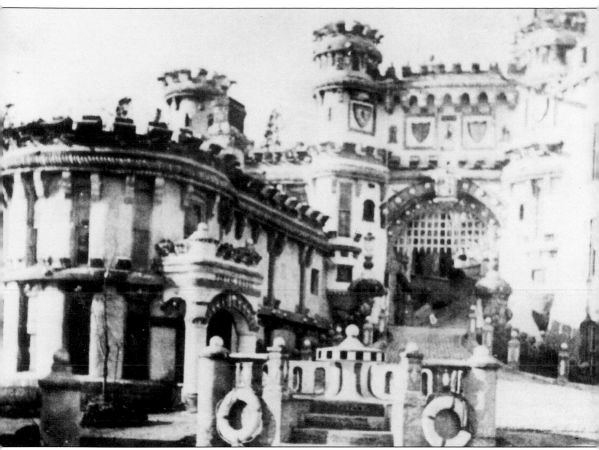

The ornate and detailed facade of Bannerman's Castle before the fire of 1969, which reduced it to charred and broken rubble. Weather, vandals, and time continue to take its toll on the castle and other buildings on Pollepel Island.

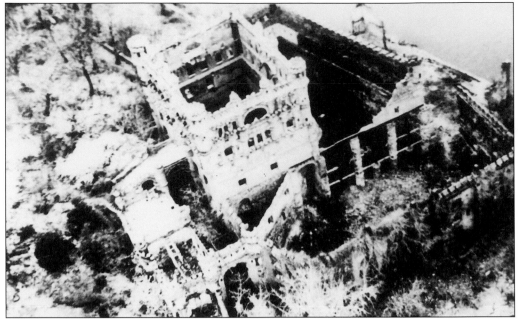

Bannerman's Island was sold to New York State in 1967, which has been holding it as an historic ruin. A fire that lit the sky for miles on both sides of the river consumed Bannerman's Castle on August 8, 1969. When the ashes cooled this was the sad view from the air.

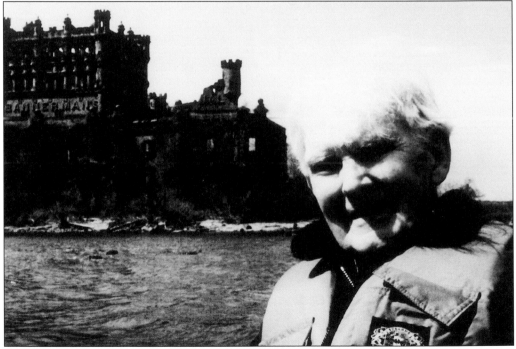

Leonard Wayne Owen was one of the last two employees on Bannerman's Island. He began his employment as a gardener in 1927 at age seventeen. When he married in 1931, his wife, Marion, joined him living in the superintendent's house. In 1942, they left the island when Wayne joined the Coast Guard. Following the war he worked for IBM. Wayne Owen died in August 1995.

Mrs. Leonard Wayne Owen (Marion) with her daughter, Eleanor, in the 1930s when they were living on the island. The family later settled in Wappingers Falls.

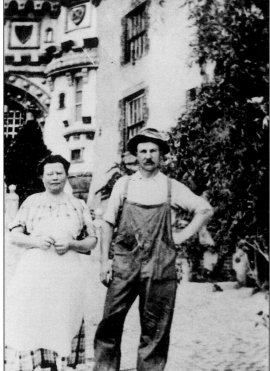

Among the first caretakers of Bannerman's Island were Charlie Kovak and his wife, pictured here before the Scottish castle on the Hudson. Note the condition of the wall and gate behind them.

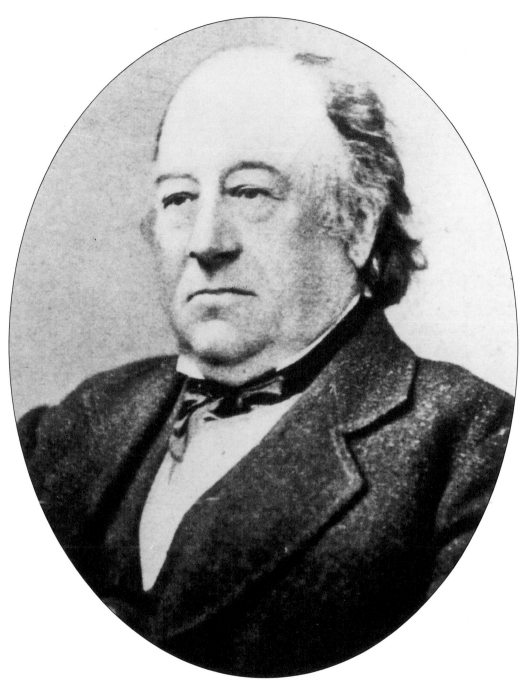

William Samuel Verplanck was born in New York City in 1812. He was a direct descendant of Gulian Verplanck, one of the original patentees. He was a lawyer by profession, but practiced for only a short time before turning his attention to the farm and flower gardens at Mount Gulian. The gardens are once again experiencing a revival. He and his wife, Harriet B. Newland, lived out their years on this lovely estate overlooking the river.

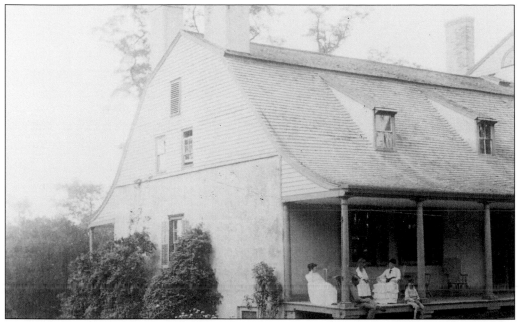

Mount Gulian was built in typical Dutch style, with gambrel roof and Dutch dormers that gracefully swept down from the roof. Seated on the porch is a Verplanck family gathering, with Mrs. David Williams and, from the left: Virginia Darby and William E. Verplanck, an unidentified girl, and William Verplanck. The three Verplanck siblings were the children of William Edward and Virginia Eliza Verplanck.

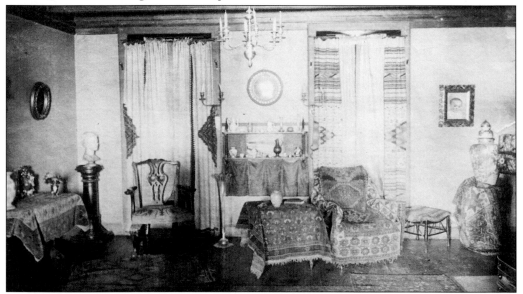

The Society of Cincinnati came into being on May 13, 1783 in this parlor at Mount Gulian at a meeting which included George Washington and Baron von Steuben. The idea for the society originated with General Henry Knox who named it after Quintius Cincinnatus who left his plow in the field to defend his country. He returned to his farm when hostilities ended. Many men in the Continental Army were farmers, who likewise left their lands to defend their new country.

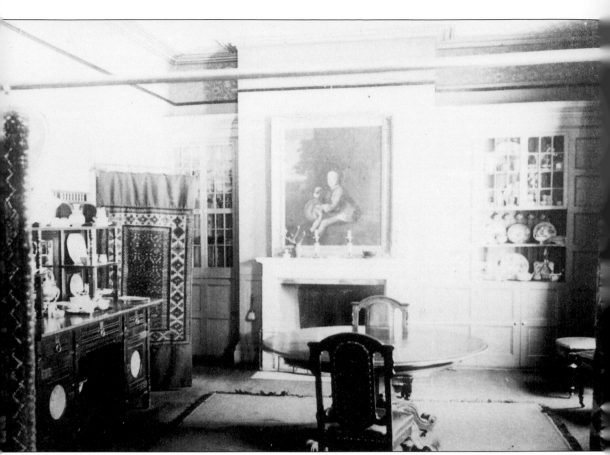

This small family parlor was located in the northeast corner of Mount Gulian. The china suggests that afternoon tea was served in this room. This photograph was taken in 1888. The John Singleton Copley painting above the fireplace is now in the Metropolitan Museum of Art in New York City. It depicts Daniel Crommelin Verplanck as a young child, holding his pet squirrel.

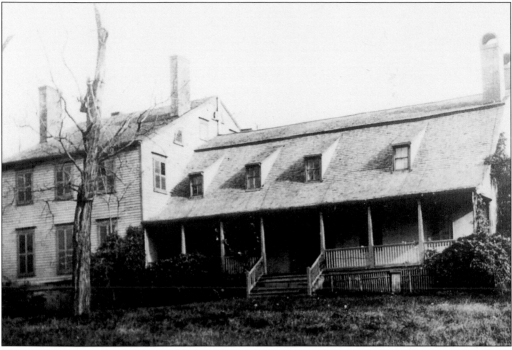

The new wing on the left was added in the early 1800s, and contained a ballroom said to have been copied after the State Dining Room in the White House.

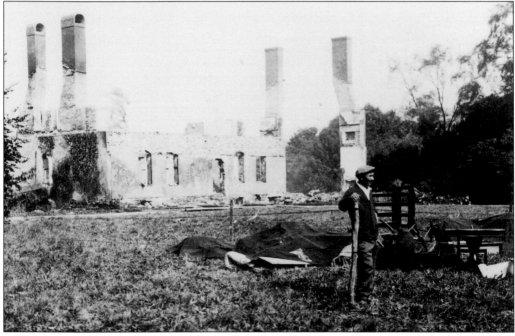

In 1931, Mount Gulian was destroyed by fire. Thirty-five years later, a committee was formed by descendants of Gulian Verplanck to rebuild the house as it was originally in 1732. It is now a museum and historic site, which hosts an annual Revolutionary War Encampment in September. Ralph Sassi, the gardener, surveys the salvaged treasures from the home.

The gardener's cottage faced west to the Hudson in 1935. It was located within the six acres of gardens that were created in 1804. There were thirteen garden beds in all, which an English soldier remarked was typical of Americans' eccentric passion for thirteen. Japanese peonies, lemon lilies, and breeder tulips were among the flowers from 1804 that were still in existence in 1923.

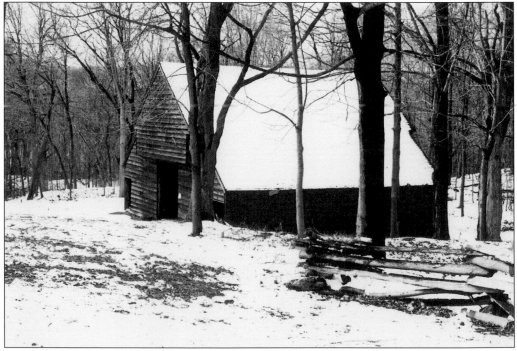

The eighteenth century Dutch barn was relocated to Mount Gulian from the Van Wyck-Stringham farm on Route 376 in 1973. Today it is the scene of craft shows, plays, concerts, and wedding receptions. The barn was built in 1726.

118

Brockway was another hamlet built by bricks. Its fortunes rose and fell with the industry that paved the streets of New York City and built the skyscrapers.

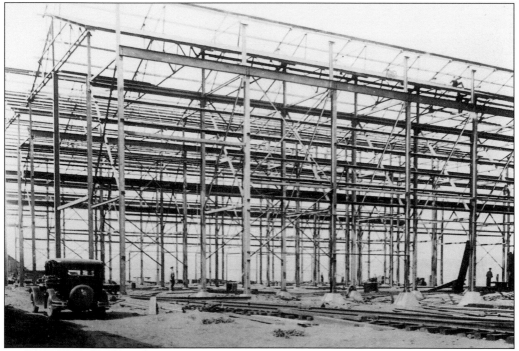

The Brockway Brick Company was located on 70 acres along the Hudson north of the Mt. Gulian property. The yard was established in 1886 by the Brockway Brothers. They purchased the yard from the estate of the late William Y. Mortimer.

Brockway School was a spin-off of the flourishing brick industry. It was built to educate the children of the brickyard employees. When the industry declined in the 1940s, the school closed. It stands as a bleak reminder of a short but glorious chapter in local history.

Brockway School was built to last. Bricks from the yard owned by the Brockway brothers were used. Rooms were large and sunny. The detail work is still outstanding to see. Quoins on either side of this door can also be found on several historic buildings in the Fishkill area. One of note is the First Reformed Church on Main Street, Fishkill.

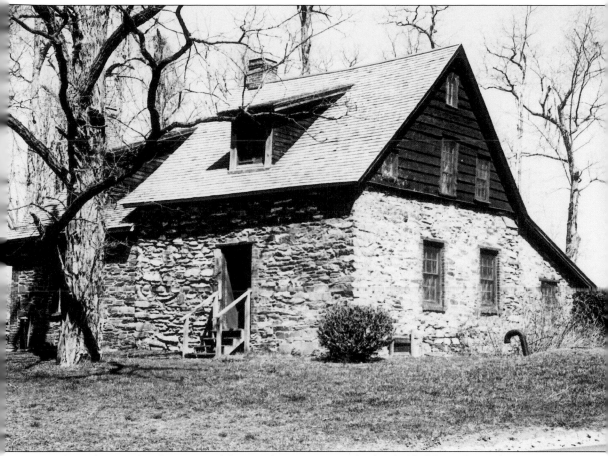

Built on the Verplanck portion of the Rombout Patent, in the first half of the eighteenth century, this pre-Revolutionary War home was reportedly used to house soldiers under the command of Baron von Steuben. The Baron was headquartered south of the farm at Mt. Gulian.

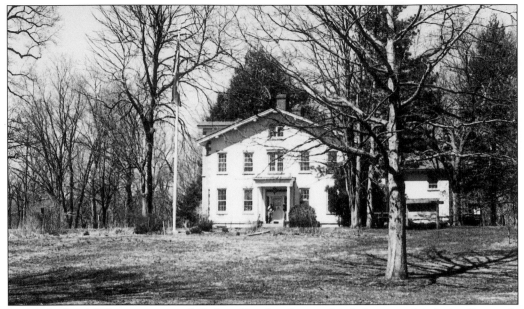

In 1836, the 6,000-acre estate of Gulian Verplanck was divided among his heirs. James de Lancey Verplanck and his wife Julia received Stony Kill and 754 acres. They lived in the small farm house until their Manor house was completed in 1843. In 1943, the property was sold to the State University of New York, becoming part of the Farmingdale Agricultural Institute. In 1973, it passed to the State Department of Environmental Conservation (DEC). The center now sponsors outdoor educational programs for all ages.

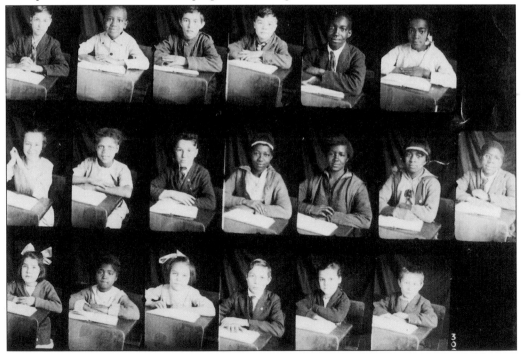

A group picture of all the students attending the Little Red School House in 1925, Children in grades kindergarten through eighth grade attended.

Miss Elizabeth Livingston, a teacher, stands with her Stony Kill Red School House students outside the one-room school in 1914. Frank Scofield is in the back row and the third young man is John Hinnrich. Anna Hinnrich stands in front of her brother.

At the corner of Route 9D and Red School House Road, across from the large Stony Kill farm complex, the school stood and served the community for 126 years. This was one of the last groups of students to attend. They are pictured with their teacher, Mrs. Travis, the former Elizabeth Livingston.

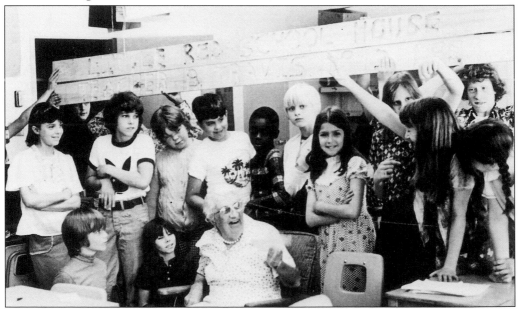

The year 1959 marked the end of an era. Mrs. Elizabeth L. Travis and her students watched the closing of the Little Red School House. It also marked the end of Mrs. Travis' teaching career, which began in 1912 in this same school. The sign being held by the students was displayed on the site after the school was torn down.

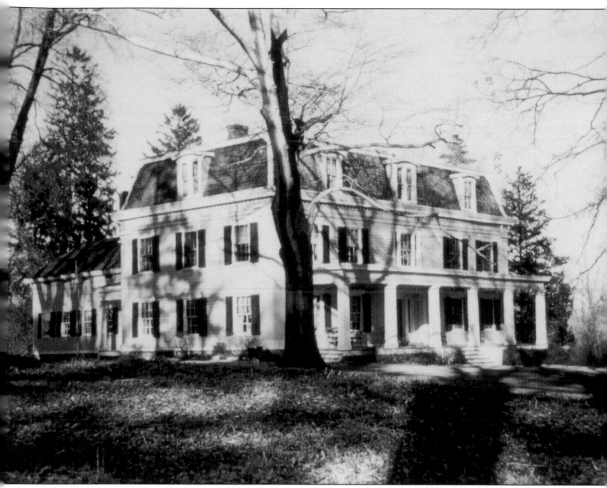

The Brinckerhoff House is one of the oldest homes in the Town of Fishkill. After it was built by Derick Brinckerhoff about 1719, residents watched history unfold before their eyes. General Lafayette recuperated in the second floor bedroom for several weeks, and General Washington and Baron von Steuben were also guests there. The mansard roof, added in the late 1800s, is not part of the original home.

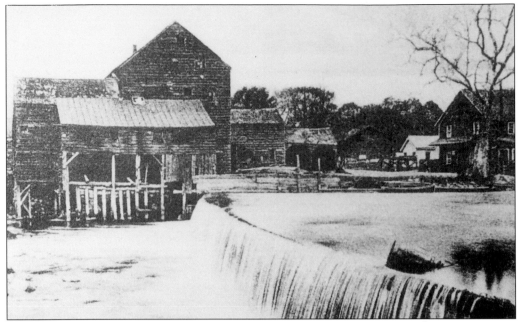

The old mill at Brinckerhoff on the Fishkill Creek was destroyed during the Revolution by a fire accidentally set by soldiers on guard duty who were trying to keep warm. It was rebuilt and stood for many years along the creek. This area was known as Brinckerhoffville. It had a general store, church cemetery, and a small cluster of homes. The road that ran in front of the house turned eastward and went into Connecticut.

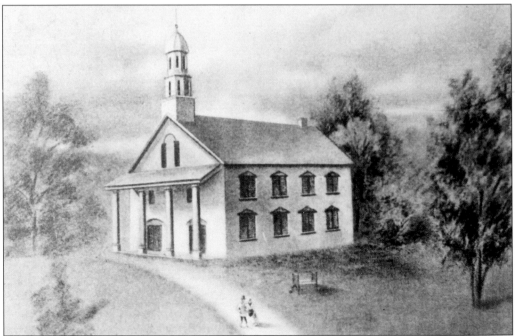

This is a sketch of the Rombout Presbyterian Church, which stood in 1746 on a knoll surrounded by graves, along Route 52, west of the Brinckerhoff home. It was destroyed by fire in 1866, and was never rebuilt. The cemetery is still used for internments.

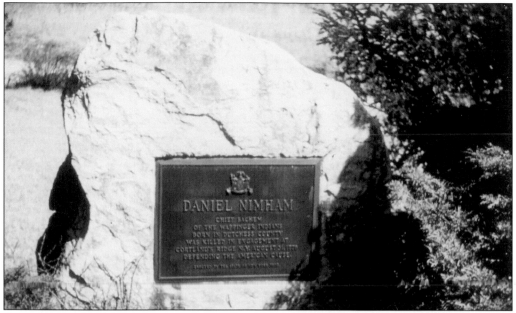

A monument to Captain Daniel Nimham, Chief of the Wappani Indians, is located east of the Village of Fishkill at the intersection of Routes 52 and 82. He was born in the Wiccopee Mountains in 1700. He was always friendly and helpful to the settlers who moved into the area. During the War for Independence, he was a valuable guide and tireless warrior. He was killed in the battle at Cortland's Ridge, New York, August 31, 1778, defending the American cause.

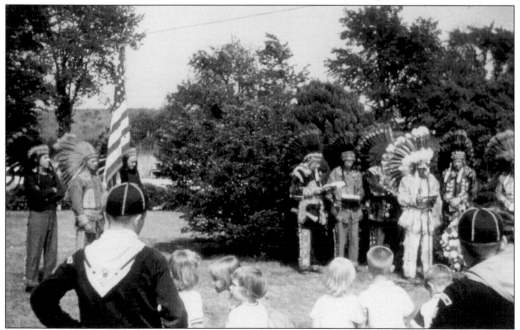

For many years, a colorful tribute to the memory of Chief Nimham was conducted by the Improved Order of Red Men, Mahwenawasigh Tribe #479, Beacon, New York, at the monument. This, too, has passed as the membership in the Red Men has rapidly declined in the last few years.

Acknowledgments

Compiling this pictorial history of Fishkill was a group endeavor. We received help from within our historical society and from the community at large. Many took that extra step of sharing their knowledge and photographs for publication. We would like to express our sincere thanks to the following: Joan Van Voorhis and Bob Murphy, Beacon Historical Society; Judge Lawrence R. Hancock; Chief Donald F. Williams, Town of Fishkill Police; Deputy Chief Allan R. Way, Protection Engine Co. No. 1 Fishkill; Sergeants George Herrmann and Robert Bessman, Fishkill Village Police Department; Nancy Foreste, Fishkill Village Clerk; Past Chief Thomas Van Buren, Slater Chemical Fire Co., Glenham; Mrs. Marion Post; Mrs. James Ortman; Mrs. Helen Lauria; Mrs. Dagmar L. Branson; Thomas Hourican; and Mrs. William Partridge Jr.

We also thank Richard Dentch, Mrs. Catherine O. Lyons; Mrs. Bertha C. Osterc; Edward J. Hogan; Douglas A. Story; Robert P. Neary; Albert Uhl Jr.; Charles Van Voorhis; Barbara Sperasio; Texaco Research Center; Neil Caplan, Bannerman Castle Trust, Inc.; Mrs. Eric Bergmann; Elaine Hayes, the Executive Director Mount Gulian Historic Site; and Robert Petrucelli.

To the Fishkill Historical Society members listed below, who researched, typed, tracked down pictures and verified information, edited our notes, and did in-house photography, we are forever in your debt.

Marilyn Coates	Nathan Dykeman	Clifford Foley
Alice Hoecker	Anita Hoecker	Toni Houston
Roy Jorgensen	Patricia McGurk	John Patterson
Karon Perry	Willa Skinner	Nancy Stoving
Doris & James Urquhart	Gloria Walker	